MYSTERY, MILLIONS
& MURDER
IN
NORTH JERSEY

MYSTERY, MILLIONS & MURDER
IN
NORTH JERSEY

THE TRAGIC KIDNAPPING OF EXXON'S SIDNEY RESO

JOHN E. O'ROURKE

THE
History
PRESS

Published by The History Press
Charleston, SC
www.historypress.com

First published 2019

Manufactured in the United States

ISBN 9781467137942

Library of Congress Control Number: 2018960982

CONTENTS

CONTENTS

ACKNOWLEDGEMENTS

I t is with the deepest respect that I first want to express my gratitude to retired FBI special agent Ed Petersen. Ed, without your help, this book could not have been written. Thanks for providing the names and information of those who worked the case and spending the time to speak with me about the investigation. I also want to thank FBI special agents Theresa Riley, Thomas Cottone and John Turkington for spending time speaking about the investigation and their roles in it. Their thoughts and perspectives were wonderful. Moreover, thanks to Chief Rich Riley of the Morris County Prosecutor's Office for showing the surrounding area where the "ransom trail" took place. Also, thanks for sharing your insight, notes and FBI newspaper collection on the kidnapping. This alone saved many hours of field research.

Steve Foley of the Morris County Prosecutor's Office, I want to thank you for sharing your perspective, notes, pictures and the diagram of the Musconetcong River search. This was very helpful. Thanks to Steve Seidler and John McWilliams of the Morris County Sheriff's Department. Their perspective on the first moments of this case helped to fill a void in the narrative that was missing.

Thanks to West Orange police chief James Abbott for introducing Arthur Seale's police academy classmate Rich Costello and Seale's Exxon subordinate Bob Crowell to me. Rich, thanks for sharing your police graduation handbook and speaking about your academy time. Bob, thanks for sharing your experience working with Arthur Seale and helping to understand the working environment of the security department at Exxon.

Joseph Tafuni, retired, of the New Jersey State Police, thank you for introducing me to retired Morris Township detective Tim Quinn, the first detective at the crime scene. Tim, thanks for speaking and sharing your experience on this matter.

Thank you, Charles Roxburgh, for sharing your experiences with Sidney Reso, your friend and boss.

Thanks to everyone who read and provided feedback on the manuscript. Thanks to Eric Falk for repairing the pictures, most of which were archived newspaper photographs, and bringing them up to spec.

I'd like to also thank my friend John Bryans, whose advice I value. If not for him, I wouldn't be writing true crime. Thanks John for taking time away from your busy schedule as an editor and consultant to offer guidance with my writing endeavors.

Lastly, I'd like to dedicate this book to my wife, Ann, and my children, John and Joanna. I appreciate your support and assistance with my writing endeavors. Love you guys.

PROLOGUE

TUESDAY EVENING, APRIL 28, 1992

The April moon shone on 15 Jonathan Smith Road, highlighting the beauty of the French Colonial set back from the street. The moon's illumination created pockets of light and darkness throughout the large property. A cool spring breeze moved through the budding green leaves, causing shadows to creep across the front lawn. The neighborhood was quiet, with hardly a car or a person to be seen other than a white van sitting in the darkness caused by a large pine tree. If someone were listening, they would hear the idling of the engine being carried by the breeze. The sound was there, amongst the rattling of branches, rustling of leaves and whistling of the wind, but no one heard it. The sun had long settled behind the dark green Morris Hills, and the residents of this neighborhood were in for the night.

Set back from the cul-de-sac and partially hidden by trees and brush, the Reso residence was dimly lit by a porch light. Several windows were aglow from lights inside. Sidney and Patricia Reso were relaxing from a long day. The solitude of their home was always a restful repose. Around 10:00 p.m., the couple strolled upstairs to their sizable bedroom. The lighting inside their abode cast softly on the fine color tones Patricia had chosen. As the two lay in bed watching TV, or simply reading, the nightstand light pierced the window pane, illuminating the leaves of an oak tree near the house. As the moon slowly moved across the sky, the pockets of light and darkness shifted, as did the shadows on the ground.

The quietness of the room and the tranquility of the affluent neighborhood were betrayed this night. For lingering amongst those dark shadows was an evil. This presence had crept into the neighborhood unseen; in fact, it had been lingering in the shadows day and night for quite some time. It was a perverse, pungent evil, filled with desire, greed and envy. Two figures sat in that van staring at the Reso home; their plan had been finalized. Once certain the Resos were tucked in for the night, the van moved slowly out of the darkness towards the home, stopping ever so briefly at the foot of the driveway before disappearing into the night.

As the hours passed, the moon continued its movement across the star-filled sky, disappearing behind the mountains just before 6:00 a.m. As the eastern hills of Morris Township came out of the shadows, the sun's light caused the needles of the pines to appear a yellowish green. Early risers began walking their dogs and going for walks as others readied for work. The clear sky, with its pure white clouds, suggested the day was going to be pleasant—the day would be anything but. Those dark souls were back in the neighborhood; much like the Grim Reaper, they were lingering in the background, waiting to claim their victim. The die was cast; their plan was ready to go. Hidden amongst the early risers was a woman dressed in jogging attire running peacefully past the Reso residence. Passing the property, she jogged up and around the cul-de-sac, taking a good look at the home set back off the street. She continued down Jonathan Smith Road, passing the driveway again, but this time, she drifted onto the property, kicking the newspaper in the driveway to the far side. Thereafter, she jogged away, disappearing out of sight. Waiting not far from Jonathan Smith Road was that white van, with her male counterpart inside.

Taking a position behind the driver's wheel, she popped the van into drive and retraced the path she had just jogged down, parking under that large pine tree. As those two dark, repugnant souls sat watching and waiting, Sidney and Patricia Reso rose to begin their day. Like clockwork, the light came on upstairs, followed shortly thereafter by the downstairs kitchen light. He was showering, while she made breakfast.

After dressing, Sidney came downstairs and sat with his wife to have breakfast. They couldn't have imagined this would be their last meal together. Nor could they have imagined these were the last moments they would spend with one another. Little time was left for Sidney Reso. He would be taking a short journey up his driveway toward his destiny. The conversation he and Patricia had was as it had always been—about their day, what they were

going to do after work, what was for supper and so on. Patricia walked with Sid to the door into the garage. She always saw him off, giving him a kiss and an embrace to start his day. Today was no different. Sid put his overcoat and briefcase in the back seat, behind the driver's seat, and got into his car. He pulled out of his garage and headed towards the street. He was driving his modest Volkswagen station wagon. As he drove up the driveway, Patricia went upstairs to begin her day.

Sid Reso pulled from the garage toward the street, slowing as he normally did to get his newspaper. Give a foot or so, it was always where he could open his door and reach down to grab it. Today it was not. He glanced to find it, noticing the paper near the driveway's edge. Putting his car into park, he stepped out to retrieve his morning read, leaving his door open. As he went to get the paper, he didn't observe the white van creeping slowly towards him. Bending over, Sid picked up the paper and turned towards his car. The van stopped, and one of those dark souls leaped from the passenger door. He was wearing a ski mask and pointed a cold steel gun into Sid Reso's face. The woman driver jumped in the back and slid the cargo door open, exposing the darkness that waited inside for her victim. There was a coldness to that darkness, silent and still, waiting for Sidney Reso. That darkness had been waiting for more than a month. Sid Reso didn't see the fate that awaited inside that van; he was too fixated on the gun and the man threatening his life. Pulling and pushing, the man moved Reso closer to the open door. One can only imagine what was going through the executive's mind as this was happening. He tried his best to comply—that is, until he peered inside the van and saw what was waiting for him. He pulled back and refused to step inside, and a struggle ensued between him and the evil soul wielding the gun. All the woman inside the van could do was watch and hope nobody was witnessing the fight. The man wielding the gun was strong and powerful, and he brought a brutal barrage of punches to the distraught executive, dislodging teeth and fillings from his mouth, some of which Reso swallowed. A shot rang out, and a bullet ripped through Reso's right forearm. The incapacitated executive was dragged into the back of the van and placed in that dark space. The woman repositioned herself behind the driver's wheel and pulled away, while the man remained in the back. The van disappeared, leaving Reso's vehicle idling near the discarded newspaper.

SEVERAL HOURS LATER

Deep, jagged breathing; long, labored, desperately gasping—if he could see, move or even take a deeper inhale, relief might come. However, little air is available. With a chest compressed by shackled arms, breathing is strenuous. An all-consuming anxiety fills every fiber; he can't reposition or prop himself up to get more air, and sweat moistens his clothing as he lies in the darkness. It is like no other darkness he has ever seen in his five decades of life— darkness that wraps around him like a cold blanket providing no comfort. Yet out of this vastness comes an array of colors and specks of light that look like shooting stars. The source of the light is not natural or artificial; it is the imaginary light people see when they close their eyes. Where he is, there is no light. If there was, it wouldn't matter, as his eyes are duct taped shut. Where he lies, there is no room for movement. He is alone, padlocked inside a wooden box—a box three feet by six feet in size in the back of a storage shed with no ventilation or windows, for it wasn't intended for human occupancy. Yet that's where he lies, placed like discarded furniture. The stagnant air is increasing in warmth with each passing minute as unseasonable outside temperatures heat the shed like an oven. His deep, labored breathing takes a toll, as more oxygen is consumed than is taken in. The breathing now becomes relaxed and rhythmic as he lies still. The unconscious state provides temporary relief until he awakens and finds himself surrounded by the horror that has befallen him.

ONE MONTH PRIOR

Bright blue skies with sporadic white clouds lingered over New Orleans's skyline as the roaring Mississippi rolled by. The warming sun evaporated the morning dew, and a city known for its cultural history was stretching its arms from the night's slumber. The oldest section of New Orleans is the French Quarter, or as the locals call it, the "Quarter." Jackson Square is at the quarter's center and is highlighted by a beautiful garden with a variety of flowers on display. Boutique shops readied for the day's activities, while street artists and musicians set up on the sidewalks. The architecture is rich in cultural influences from the French, Spanish, Irish, Italians and Africans who laid anchor in the port on the Mississippi. Much of the architecture was built by Spanish hands, and beautiful structures are abundant. Corner buildings have large balconies wrapping around the exterior with wrought iron railings highlighting colorful floral displays. In fact, most structures in the quarter have wrought iron railing, and an equal number of homes have stucco veneers that are colorfully painted in pretty pastels of pink, salmon, yellow and blue, each with bright shutters of varying colors to flaunt their exteriors.

Decatur and Rampart Streets were growing in pedestrian traffic as the morning sun heated the city streets. Bourbon Street, perhaps the most recognized street in the Quarter, was bustling with tourists. Horse-drawn carriages lined the street with their coachmen readying for the day. Neon signs hung everywhere, some dimmed from last night's activities, while many were still aglow, dimmed only by the morning sun.

In the distance, the Port of New Orleans, with the longest wharf in the world, was full of boats and vessels of all sizes. The roaring Mississippi's rough waters swayed the boats in the harbor and slapped loudly against the pier. A bit farther inland, the Louisiana landscape was ripe with azaleas of pink, purple, red and white along with Chinese fringe trees, orchids, petunias, poppies and snapdragons; all were beginning to bloom with the spring warmth. The day was projected to have continuous blue skies with warm temperatures and a mild breeze. People were out in droves trying to make the most of a wonderful day.

Not far from the quarter, the board of directors of Brother Martin High School assembled for what was going to be a busy day. They were preparing for a midday celebration honoring a past student. The luxurious hotel hosting the event began welcoming attendees around half past eleven. The spacious room they had selected for the event filled quickly with familiar faces. A mix of laughter and chatter filled the air as people gathered. Large chandeliers lighted the room, and the formal tables were dressed in pearl-white tablecloths and glittering silverware.

Each year, Brother Martin High School hosts this event to recognize a former student who has made a mark in the world. Brother Martin High School was essentially a mix of two former schools that had closed, St. Aloysius and Cor Jesu High Schools. The school is named after Brother Martin Hernandez because of his leadership in navigating the controversial closure of both schools. The mortar was not yet cured for the new school when, in 1972, Brother Martin began honoring distinguished past students with the Senator Allen J. Ellender Alumnus of the Year Award. Allen J. Ellender was a former St. Aloysius student who served thirty-five years in the U.S. Senate. Brother Martin High School prides itself on its holistic education, with a methodology and teaching style that asserts a solid foundation for life's journey rooted in spirituality and discipline.

Past students, old staff and former recipients of the Ellender Award were in attendance on this day. Prior recipients of the award were medical doctors, lawyers, hotel executives, bank officials, media and marketing professionals, archbishops, accountants and engineers. This year's honoree was a man from the energy field who graduated from St. Aloysius four decades prior. Like many past recipients, he was highly respected in his industry. Those familiar with the nominee could see him sitting at the main table looking distinguished with his salt-and-pepper hair, thick black glasses and finely tailored suit. He wasn't a big man, standing a mere five feet, ten inches and weighing about 180 pounds, but somehow, this man stood out. His wife,

sitting beside him, was equally dignified, with her neatly groomed gray hair. Sidney and Patricia Reso had flown from New Jersey to attend the ceremony. Reso, the honoree, and his wife were both from New Orleans. Sidney, or "Sid" as his friends called him, was in good spirits and spent a considerable amount of time catching up with old acquaintances. Sid Reso had traveled and lived in many locations throughout his long and illustrious career.

As people reminisced, those who hadn't seen Sid in years noticed a much older man whose red hair had darkened and grayed. They were equally surprised to see he was the same person they had once known. Rising to the heights of Exxon, as he had, might change a man. It did not change Sid Reso. He was a down-to-earth person, one who was humble and not ostentatious. Ceremonies such as this often evoke thoughts of years gone by and distant memories; presumably, Reso wasn't immune from these feelings. It's likely he thought back to when, at seventeen, he met his future wife Patricia Armond at a Catholic Youth dance in town. Many years had passed since that night, and the two had experienced joy and heartache with an unending love for one another.

Sid Reso was a good man—quiet, reserved and intelligent, a highly successful businessman who seemed like the guy next door. He was born to James and Josephine (née Schindler) on February 2, 1935, in the city of New Orleans. His parents were of modest means and lived at 6850 General Diaz Street. James and Josephine had seven children and were devout Catholics. Sidney's religious upbringing left an indelible mark, and he remained devout as well. As a young man, he enjoyed fishing in Lake Pontchartrain, an estuary not far from his home. There, Sid could catch loads of flounder, red drum and speckled trout, all of which were abundant in the lake.

St. Aloysius was positioned in the Quarter and was an all boy's school, which allowed Reso while in attendance to focus on his studies rather than the opposite sex. He was an aspiring engineer who had high goals, and his performance is indicative of discipline. After spending a year proving he could do his academic studies, Sid joined the Crusader football team in the fall of his sophomore year. A 1950 team photograph shows a curly-haired Sidney Reso sitting in the middle of the team looking confident in his abilities and proudly displaying his uniform number, twenty-six. Reso was an offensive guard, which required speed, agility and strength, all of which the young athlete had.

The 1950 football season, led by head coach Eddie Toribio, proved to be difficult, as Toribio had few juniors or seniors on his team; his varsity team consisted mainly of sophomores and freshmen. This opportunity led to Sid

Reso becoming a starter early on. The season was a challenge for coaches and players alike, as they faced older and more experienced players week after week. Tensions were high and expectations low on their opening night, Thursday, September 21, 1950. Their first game took place at Memorial Stadium in the city. To everyone's surprise, they won the game, 6-0. This left everyone with unrealistic high hopes. As it turned out, the Crusaders concluded the season with a record of 4-6. However, two years later, Toribio took this same team to the state championship with Sidney Reso as one of his guards.

After graduating from St. Aloysius, Sid began his studies at Louisiana State University in Baton Rouge, which was seventy-five miles from his home. Louisiana State is rich in history, having opened its doors in January 1860. The university's first superintendent was William Tecumseh Sherman, the future Civil War general. Shortly after the university celebrated its first anniversary, the State of Louisiana seceded from the Union, wishing to become part of a "Southern Confederacy." The specific reason for Louisiana doing so is not known, because the state never published a declaration of cause. It goes without saying that Sherman was opposed to the secession and stepped down from his university position to head north. Through the years, Louisiana State University evolved into a highly respected institute of higher learning. In particular, the university was known for having the best petroleum engineering program in the nation—a curriculum of interest to Sidney Reso.

By 1952, the campus of Louisiana State had grown considerably since the days of Sherman. By the time freshman Sid Reso was walking the campus, over a hundred buildings were spread throughout six hundred acres of prime property on the banks of the Mississippi River. The campus is full of Italian Renaissance architecture and neatly manicured landscapes. The solitude of campus life was offset with real-life events, including international tensions between the Soviet Union and the United States. The Soviets were moving fast with their atomic bomb project, which caused the United States to assume a strong military posture. This was the early period of what was to be known as the Cold War. Students at all levels of academic study soon became accustomed to bomb drills, which included hiding underneath their desks. While students on campus worried about their course of study, the threat of communism was on the rise due to Russian expansion. People across the country were concerned about the "Second Red Scare." (The first took place at the end of World War I and centered on the expansion of communism.) The Second Red Scare is more commonly known as McCarthyism. Due

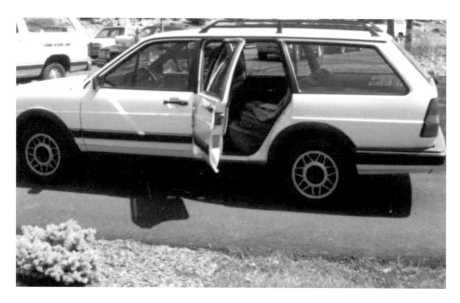

Crime scene photograph of car in driveway. *FBI crime scene photograph.*

to tensions running high, government officials were making accusations of subversion or treason against American citizens without substantial proof to support their claims. It was a period of extreme paranoia, with Senator Joseph McCarthy leading the cause.

The U.S. House of Representatives formed the House Un-American Activities Committee. Out of this rose many accusations against American citizens, many of whom were notable. Hollywood blacklists began prohibiting screenwriters, actors and directors from gainful employment if they were suspected of political beliefs contrary to the interests of the United States. Concerned supporters of the campaign against the communist threat included Walt Disney and Ronald Reagan, while film legends John Huston, Humphrey Bogart and Lauren Bacall were against such tactics.

Despite these tensions, somehow teenagers across the country were immune from the worries and concerns their parents were enduring. This was a time when kids were wearing bobby socks and listening to soft ballads on the radio airwaves. Boys were neatly groomed with crew cuts, while girls adopted short curly or wavy hairstyles they called the bubble and poodle cut. Television programs such as *I Love Lucy* and *The Life of Riley*, as well as motion pictures such as *Singing in the Rain* and *The Quiet Man*, helped people escape into the imaginary world of Hollywood. Through this mix of tension, laughter and imagination, a young Sid Reso was roaming the

hallowed corridors of Louisiana State during his freshman year aspiring to be an engineer.

The course of study in petroleum engineering was less than a decade old at Louisiana State, but in that short period, it had become regarded as the best in the country. The curriculum was difficult, with courses in geoscience and petroleum, chemical, biological and agricultural engineering. Enrollment for the program was high, but acceptance into it was difficult; only a select few would bear that honor.

When Reso concluded his tenure at Louisiana State in 1957, he graduated in the top seventeen percent of his class. A lot had changed since he began his studies. Sid and Patricia had married and were now parents. The softer sounds of crooners transitioned to the faster, up-tempo beats of rock and roll with the popularity of a man named Elvis. Teenagers were now growing their hair longer and were dressing more provocatively. After graduating, Reso gained employment as an engineer at Humble Oil & Refining in New Iberia, Louisiana. Humble Oil was formed in 1911 in Humble, Texas, and had recently merged with Standard Oil, which before long would become part of Exxon. New Iberia was in such a remote area of Louisiana that the assignment here was known as "New Siberia."

Under the heat of the Louisiana sun, Sid rolled up his sleeves and got right to work proving to his superiors what he was made of. Somehow, the ambitious worker identified an area of untapped oil and literally hit pay dirt. This discovery put Sidney Reso on the minds of senior executives. During the following decade, Sid would climb the corporate ladder with his hard work and intelligent mind. He was promoted to division manager in 1973 and a year later was manager of production operations.

Each promotion brought new challenges for the young engineer, but somehow, he rose to overcome each obstacle encountered. When an opportunity arose for Reso to run the operations in Australia, Patricia and he moved their family to that remote location. Working as the chief engineer of Esso Standard Oil—an Exxon trade name—Reso was instrumental in the Land Down Under in developing newly discovered offshore oil and gas reserves. This success lead to another promotion, placing Reso at the head of the corporation's Natural Gas Department; this position, according to a *New York Times* article, had Reso overseeing "the marketing of natural gas in Australia and throughout the Far East."

By the mid-1970s, the Resos were living in London, England, where Sid was the vice president of Esso Europe, another trade name of the expanding Exxon company. Sid and Patricia would live here until the close of the

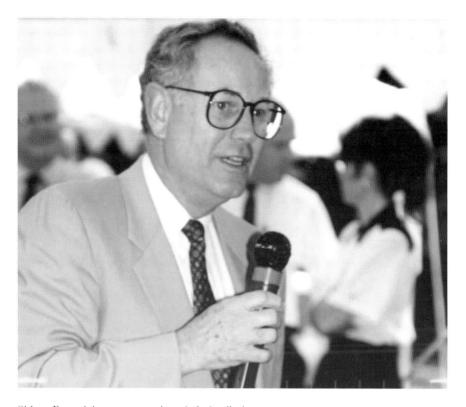

Sidney Reso giving a presentation. *Author's collection.*

decade, when another promotion came his way—this time as vice president of production for Exxon Company USA, which meant he and his family would be returning to American soil.

The St. Aloysius graduate had forged his place in the energy field, and Reso's reputation proceeded him. In 1983, his alma mater, Louisiana State, honored him with its prestigious Alumnus of the Year Award. During that ceremony, the university said Sidney Reso had the "highest qualities of managerial and administrative leadership…and [was] admired all over the world." When Sidney Reso stood at the podium to accept his award, he was humbled and proud. He told those in attendance that it was their role "to continue to beneficially expand the material productivity of society…by garner[ing] the rapidly expanding scientific knowledge and to apply it consistently with a clear vision of the world and within the systems of value to which one subscribes." That was the key ingredient for Sid Reso: values. His parents subscribed to them, and so did he. What

Sidney Reso probably didn't realize was the indelible mark he was making in his industry. Those future engineers were being told by one of the most successful people in the industry that they must not stray from their values. And while accepting the Senator Allen J. Ellender Alumnus of the Year Award in New Orleans, Sidney Reso echoed his feelings on hard work, dedication and family values.

MORRIS TOWNSHIP, NEW JERSEY, SPRING 1992

The state of New Jersey is often misunderstood by nonresidents. Those traversing the state seldom see its natural beauty. Rather, they tend to think of the New Jersey Turnpike, with its miles of black macadam lined with large oil refineries billowing noxious smoke. Another optic is the large red containers and yellow containers stacked on top of one another in the ports of Newark and Elizabeth near the Newark International Airport. Moreover, of the fifty states, New Jersey is the most densely populated and is the forth smallest in landmass. These observations are of course true but don't tell the whole story of the "Garden State."

New Jersey is divided into five different regions, with the Gateway region being the one many passing through the state are familiar with. This region sits in the shadow of New York City and is the direct suburb of the metropolitan area. This is the area of oil refineries and shipyards. It is also the region where most of the state's populace resides. Newark and Paterson are the two primary cities in this urban area. The Delaware Valley region is the second urban area, where Camden rests. This part of the state is also known as the Philadelphia metropolitan area, because the City of Brotherly Love sits across the Delaware River. The Shore region, which has been popularized by the TV show *The Jersey Shore*, is a fun recreational place Jerseyans visit on day trips and for long weekends. The Shore runs from Sandy Hook south to Cape May and offers clean wide beaches, boutique shops and fine dining. Though this is a beautiful part of the state, there is still much more New Jersey has to offer. The Pine Barrens region is a dense forest

in the coastal plain that runs through seven counties in the southern part of the state. This flatland is comprised of oak and pine trees, and those driving the southern portion of the Garden State Parkway get a small glimpse of the Pine Barrens. The Skylands region is filled with rolling hills, open farmland and high-rising mountains. Two national parks are present here along with an additional 60,000 acres of state parkland. The crystal-clear ponds, lakes and rivers are enjoyed by hunters, fishermen and swimmers. Highlighting this region are the large and picturesque Appalachian Mountains, which sit high above the flowing Delaware River. The counties of Hunterdon, Somerset, Passaic, Warren and Morris are part of this region.

Hunterdon and Morris are the two most affluent counties, and properties here have open fields, long private driveways and large estates. The communities in Hunterdon and Morris are small hamlets, and many do not have their own police departments. These are sleepy towns where crime is unheard of, yet when a crime does occur, it seems to be so horrifying that national attention is brought to the area. On a dark night in March 1935, one such crime occurred. Renowned aviator Charles Lindbergh was resting in his large estate in East Amwell, Hunterdon County, when unbeknownst to him and his wife, his child was kidnapped and killed. Many years had gone by since that horrific crime, and since then, a few notable crimes had been committed in New Jersey. In the spring of 1992, another horrific crime was about to shock another sleepy community. The community was that of Morris Township in the county of Morris.

Those familiar with American history know all about Morris County and the significant role it played in the Revolutionary War. Today, many homes built during the colonial era still stand within the county, and many of the newer homes are designed with a touch of the colonial era. Then there are the national parks within the county that are visited in the droves by sightseers. The hamlet of Morris Township surrounds the historic community of Morristown. Because Morris Township encapsulates Morristown, it is often referred to as the "doughnut."

Spring this year was warmer than usual, and it seemed every day brought lingering white clouds and blue skies to the region. On this particular weekend, an early-morning shower moistened the green grass and walkways of the historic Morristown Green, not far from the residence of Sidney and Patricia Reso. The park was full of people, some walking their dogs, others strolling between the local shops that surround the small park. This little green has been the central point of Morris County for more than two hundred years. The soil here is rich in history—the green once housed

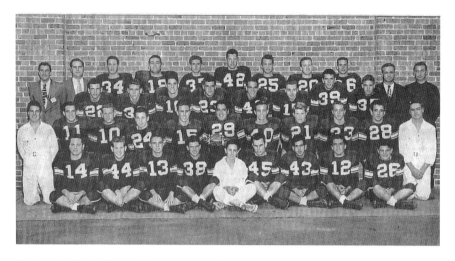

St. Aloysius Football team. Reso is number forty-four. *www.bluejaystigers.com.*

an encampment of the Continental Army during the Revolutionary War. General George Washington headquartered at Arnold's Tavern, which sat on the northwest corner of the green. Today, a marker memorializes the exact location. This area was also the site of the Morris County Courthouse and Jail and became a gathering point for public executions. The last man executed here was Antoine Le Blanc, a French-speaking immigrant. Le Blanc murdered Samuel Sayre and his wife at a farm on South Street, not far from the green, in 1833.

Today, thousands of visitors enjoy the green grass and the shade of the trees on this two-and-a-half-acre parcel of land. At the entrance to the green, visitors are greeted by the Patriot's Farewell monument, which sits over a water fountain. The statue depicts a Continental soldier, fit and standing tall, saying goodbye to his wife, who's holding their newborn baby. A young boy looks on with pride as he pets his dog. The pathways through the park are lined with colorful flowers of purple, yellow and red, and green hedges create unique landscape designs. Deeper inside the grounds sits a towering Civil War monument dedicated to those who served during the country's bitter war. Walking the park's pathways, spectators see bronze life-size statues of George Washington, Alexander Hamilton and the Marquis de Lafayette immersed in conversation. The statues were meant to invoke emotions of the country's foundation and the great men who once stood on this parcel of land. In recent times, the green is used for seasonal events as well as political gatherings. In winter, there is a Christmas tree lighting ceremony, whereas

in the spring and fall, there are outside fairs and festivals. In summer, a large block party is held, with thousands normally in attendance.

A brief walk from the green sits the Grand Café, a French restaurant frequented by Sid and Patricia Reso. Many Saturday nights witnessed the couple dining at the restaurant. The restaurant's owner, Desmond Lloyd, said Sid Reso "tried most items on the menu." The couple ate here so often that Lloyd got to know them well. Sid's favorite item on the menu was the rack of lamb. Often, Sid and Patricia would sit tucked at a table, holding hands, joking with one another and sipping on Bordeaux wine. After dinner, they would slip over to the bar for drinks and listen to pianist Linda Ferri playing tunes composed by Beethoven and Mozart. Both Sid and Patricia loved classical music. Those familiar with the couple have said they often overheard them at the bar having "intense philosophical conversations." Lloyd said the Resos were "a lovely couple…very much in love."

As it turns out, Sid Reso was a creature of habit. He woke every morning at the same time; he had breakfast at the same time; he left for work at the same time; and he took the same route to get to work and to come home. The executive's life was a predictable routine. It's possible that Sidney Reso's daily patterns were because of a complex and everchanging work environment—a standardized routine while not at work may have had a calming effect on him. His neighborhood certainly was a quiet respite from Exxon's busy campus.

Jonathan Smith Road is a tree-filled street with homes set far back. Morris Township itself is filled with tree varieties such as boxelder, yellow buckeye, bear oak and blackjack oak, all of which were beginning to show signs of blooming at this time of year. The trees lining Jonathan Smith Road are a mix of eastern hemlock, shortleaf and pond pine. Each offers a different shade of green. Some were planted by Mother Nature, while others were planted for residential privacy.

Normally in April, hints of the large homes are visible from the street, but by month's end, most will be secluded with the budding of leaves. A considerable number of dense trees block clear views of the Reso home at 15 Jonathan Smith

Patricia Reso. *From the* Star-Ledger, *photograph by Robert Eberle.*

Road in the deadest of winter. The French Colonial with a light-colored brick facade sits on five acres of prime Morristown property, with curbside appeal unmatched by other homes on the street. The front and side yards are a mix of grass, trees and brush, with fine landscape themes providing hints of the home through the thick foliage. A long pathway brings visitors through a mix of landscape designs and woodland, making the walk to the front door seem like a stroll through a park. Those more familiar with the family can take the two-hundred-foot driveway, which provides an optic just as appealing. The house itself is a spacious five-bedroom, six-bath residence comprised of nearly five thousand square feet of living space. Vaulted ceilings, fine moldings and interior designs are hard to miss for those visiting. The interior decorations are modest, and music from the 1940s and 1950s is often played over the home's audio system.

Nights had quieted from the days when their children were huddled together under one roof. In those passing years, tragedy struck when their son Gregory became ill and passed away. The loss left an unimaginable void in their hearts. It is said that the couple's faith and love for one another is what got them through. Their home had always been a respite for the couple. It seems the living room was the place Patricia and her husband spent most of their time. Patricia's favorite spot was a large chair snuggled close to the fireplace, while Sidney sat close by reading a book. History and leadership books were frequent favorites of his. Both Sid and Patricia were enthusiastic readers and were extremely interested in current events. Many of the news events for the new year brought about interesting discussions between the two.

The year of 1992 was stacking up to be full of newsworthy events. In January, President George H.W. Bush, while sitting at a table, fell over onto a lap of a foreign leader and vomited; the incident was broadcast on the nightly news. This same month, Russian leader Boris Yeltsin announced that his government would stop pointing his nuclear weapons at American cities; this put an end to the Cold War era. February witnessed boxing champion Mike Tyson being convicted of rape and looking at considerable time behind bars, while the political news was proving just as interesting.

The political landscape was fascinating and centered around the upcoming presidential election. The sluggish economy, coupled with President Bush raising taxes despite saying "Read my lips, no new taxes," caused his approval rating to plummet. Then there was the vibrant William Jefferson Clinton, who came out of nowhere and proved to be a strong contrast to the sitting president. Clinton offered a new direction after twelve

Morristown, New Jersey, near the green. *www.njtgo.com/towns/M/Morristown/Morristown.html.*

years of Republican rule. But if that wasn't enough, billionaire Ross Perot announced his run for president. Many citizens had no idea who he was. However, Ross Perot quickly became popular, and it looked as if he could be a viable alternative to the two political parties as he ran as an independent.

It seemed the nightly news was more entertaining than the serial programs being shown. New York Gambino crime family head John Gotti was a popular figure in the Tri-State Area who for years filled many a nightly news story. Known as "Teflon Don" because authorities could never pin a crime on him, he had just been found guilty and sentenced to life in prison for murder, conspiracy to murder, loansharking, illegal gambling and obstruction of justice. Sports broadcasters had announced the news of tennis great Arthur Ashe having contracted AIDS. Then there was the nightly news coverage of the Rodney King assault trial—King had been brutally beaten during an arrest. The video of the four Los Angeles police officers hitting King with their nightsticks played continuously on the television, and what was missed by Sidney Reso on the evening news he caught up with in the mornings reading the newspaper. The *Star-Ledger* was his paper of choice, and he had it home delivered and waiting for him each day at the foot of his driveway.

MYSTERY IN SLEEPY MORRIS TOWN

APRIL 29, 1992

As the morning dew evaporated from the plastic bag holding the newspaper on the driveway, Reso's vehicle sat idling for more than an hour before being noticed by next-door neighbor Deborah Reynolds. The morning temperature was mild, and a gentle breeze brushed against Reynolds's face as she glanced over at the running car. Reynolds's husband worked in the human resources department at Exxon, and it had been a while since she saw Sidney Reso, so she walked over to say hi. When she neared Reso's driveway, the sun's glare prevented her from seeing inside the car, so she assumed Sid was in it. After all, she could hear the engine running. She approached the car with a smile on her face to say good morning but was greeted by an empty driver's seat. The door was still open. Reso was nowhere to be found. It felt odd and a bit troublesome. Not wanting to trouble Patricia or alarm her immediately, Reynolds called her husband, who was already at work. She asked him to check if Sidney had arrived at work. Possibly a limo picked him up and he accidently left his car running. Who knows what Reynolds was thinking, but it was odd that the car was abandoned at the foot of the driveway and still running. Reynolds's husband called Reso's secretary, Barbara Crookshank.

As executives at Exxon tried to locate Sid Reso, Patricia had begun her normal morning routine. After seeing Sid off to work, she spent some quiet time in the comfort of her room and then took a shower. When she was

stepping out of the shower, the call from Sidney Reso's secretary came. Patricia knew Barbara Crookshank's voice and figured she was calling to relay a message from Sid. "Is Sid inside with you?" Crookshank asked. Having seen her husband off to work more than an hour ago, Patricia was surprised by that question. "No, why?" There was a momentary period of silence before Crookshank responded, "Deborah Reynolds called and said Sid's car is in your driveway and he's nowhere to be found." The chill running down Patricia Reso's spine was not the chill from the moisture she still had on her body from the shower. Patricia hurried to the window and peered out, looking down the long driveway. Her view was partially blocked by their thick tree line, but there was Sid's car.

Hurrying down to the driveway, Patricia said, "I opened the back door… and his briefcase and his coat were in there." It was abundantly clear something was wrong. "I just stood watching them," meaning her husband's belongings. Then reality set in, and "I began to feel afraid."

Meanwhile, at Exxon headquarters, security agent Bob Crowell was told by Crookshank of Sid's disappearance. Crowell deployed a security team to the residence and didn't have a good feeling about what was transpiring. Sid was a "great man," said Crowell. It didn't seem that long ago that Crowell himself went to the Reso home and installed their security system. When Patricia Reso called the Exxon security office, Bob Crowell answered the phone and ensured her "security agents were en route" and the police had been notified.

When the call sounded on the police channels that someone was reported missing, sheriff's investigators Steve Siedler and John McWilliams responded to the scene. Both investigators were K9 handlers who responded to have their dogs track Reso's scent; if he wandered off, the dogs would be able to find the path he took. "When we arrived," said Siedler, "there was one patrolman to greet us." The officer told the two sheriff's deputies that Reso had "health issues and had recently had a heart attack." The officer did not say a word about Reso's position at Exxon. "I don't know if he even knew it at this point," said Siedler. "However," he continued, "the cop did not walk around willy-nilly prior to our arrival, knowing we preferred an uncontaminated scene." With an uncontaminated scene, Siedler and McWilliams were sure they could track Reso's scent. "The weather was perfect for tracking," said McWilliams.

"I utilized my K9 dog named Heavy," said Siedler. "I began at what we call the 'starting point' where we know Reso definitely was. In this case, with his driver's door open, we knew he stepped out. That was where I brought

Heavy and placed him in a down position directly below the vehicle where Reso's feet would have been." With the officer and McWilliams watching, Siedler "commanded Heavy to pick up and follow a trail of human scent." The seasoned investigator did not lead the dog but let the dog go on his own. "Heavy did not track more than a few feet to the side and towards the vehicle's front," Siedler recalled. "I allowed Heavy to work out possible scent unimpeded by me and controlled his leash very loosely." With the scent stopping at the front of the car, Siedler let the dog sniff around the vehicle with the hopes he would pick the scent back up. However, Heavy couldn't locate Reso's scent any farther.

With no success, Siedler implemented what he refers to as the "spoke of the wheel" technique. Basically, this technique is where the dog searches outward from an imaginary circle around the car like spokes of a bicycle wheel. This is done with the hopes that the dog will regain the trail or scent of the missing person. However, this technique proved ineffective, as the dog did not react in a positive manner and did not pick up Reso's scent.

With this technique not working, "John and I used a technique called 'pushing.' " Starting from the imaginary circle drawn around the car, Siedler took one side of the vehicle and McWilliams the other. "I was using my dog Elkas," said McWilliams. Working together, the two K9 investigators used a "combination of scouting and evidence recovery." In doing so, they looked for any footprint impression on grass, cigarette butts, wrappers or anything else that looked out of place. After a lengthy effort, both McWilliams and Siedler were mystified. "It's one thing to not finish successfully," said Siedler, "That happens a lot. Quite another to not even get past a few feet without some logical explanation." McWilliams said, "After finding nothing, we floated the possibility of Reso being kidnapped as the only viable explanation."

The findings of the dog search and the determination by the investigators was reported to police headquarters. "I was working the afternoon shift," said Morristown detective Timothy Quinn, "when my phone rang." Quinn had just finished breakfast and was enjoying a cup of coffee when the phone sounded. The voice on the other end said, "We got a possible kidnapping up here." Before the detective could respond, he heard, "Can you come in to work?"

Timothy Quinn was one of only a handful of detectives on the small police force. He had over a decade of experience with the department, beginning with a stint as a dispatcher back in 1978. If the passing years had taught him anything, it was how to investigate. He was good at it. Even as a uniform cop, his skills were evident, which is why he landed a detective

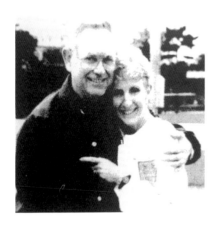

A loving couple. *Associated Press photograph.*

position. "Yeah," said Quinn. "I'll be up shortly." Looking back on that call with some levity, Quinn said, "I headed up there and went home about two months later."

Pulling in front of 15 Jonathan Smith Road, Quinn could see that the scene had a mix of uniformed and plain-clothed police officers milling about. Adding to the confusion was the growing number of spectators wondering what was happening in their affluent neighborhood. Police efforts when he arrived looked a little disjointed. The two Morris County K9 deputies had offered their assessment that Reso had likely been kidnapped. However, officials were still adamant about working on the assumption that the executive had become ill and wandered off. The tall, slender detective had an air of confidence that helped calm the nerves of the uniform cops scurrying around. Quinn inquired about the executive's spouse and was told she was inside the home.

The detective walked to Reso's car and, before nearing it, examined the area for clues. By now, the open driver's door was closed, and some scene contamination had taken place. Quinn isolated the car and began controlling access in and around it. If, like the deputies had suggested, he was dealing with a serious crime, evidence needed to be preserved. There were no indications of a struggle or indications of any belongings dropped by Reso. He had simply vanished. As Quinn walked inside to speak with Mrs. Reso, K9 officer John McWilliams brought his dog inside the Reso home to search there.

In short order, the search efforts were beginning to take on a more organized approach. Uniformed and plain-clothed officers were sent from house to house to inquire if they had seen anything. Janet Boni, the neighbor across the street from the Reso residence, told investigators that the Resos were "busy people" and that her "children are not at the ages that we meet people." Jackie Deskovic, a few homes down on Jonathan Smith Road, was unnerved by the news of her missing neighbor. She told authorities she couldn't imagine anyone "try[ing] to hurt this wonderful man." Deskovic said she found it "so eerie…to think that someone came into the neighborhood"

to kidnap Reso. The officers, however, weren't ready to call this incident a crime. For now, it was being treating as a missing person case.

More than two hours had passed since the discovery of the missing executive. The initial search efforts, which included the woodland in front and Reso's backyard, had proved negative of any evidence whatsoever. There simply were no clues to what happened. By now, even the junior officers knew this was a crime scene.

As these early efforts were taking place on Jonathan Smith Road, chief of detectives Rich Riley of the Morris County Prosecutor's Office was sitting in a makeshift jail cell in a mall on Ridgedale Avenue. Riley was participating in a charity event for the American Cancer Society. Every year, the fundraiser casts police officials into a mock cell they cannot be released from until they raise a predetermined amount of "bail," which will be donated to the charity. This was a popular event, with many law enforcement people giving their time to raise money.

Sitting in his pretend cell with a landline phone, Riley was calling family and friends to raise money when the beeper on his belt vibrated. He had told his secretary not to bother him unless it was important, so he twisted the beeper on his belt and looked down to read the message. It simply said "911."

Riley picked up the designated landline "bail" phone and called his office. "What's the problem?" he asked. He was told, "We have a missing Exxon executive in Morris Township on Jonathan Smith Road."

Chief Riley called out to his assistant, Jack Dempsey, who was participating in the fundraiser and sitting in the cell adjacent to his. "Let's go," Riley told Dempsey. Dempsey didn't know what it was they were going to, but he knew it was bad.

Policing was in Rich Riley's blood. As a child, his idol was his dad, who was a police officer. Oscar "Bing" Riley was an impressive figure—if not to all then at least to his little boy. The influence and knowledge his dad imparted on him was ever-present in Riley's mind. When Riley first became a cop, police radios were a scarcity, and callboxes placed strategically throughout town were the primary means of communicating with headquarters. Policing had come a long way since then, and so had he. Now, he was the chief of the prosecutor's office and was running the show for all things investigative in Morris County.

The sun was high above the roof of the Reso home and the outside temperature was lingering in the upper sixties when Riley and Dempsey arrived. Even with the distraction of all the police activity, Riley couldn't help

admiring the large property and house sitting off in the distance. Despite the efforts of Quinn to keep structure to the investigation, the minute-by-minute arrivals of assisting officers made for a hectic scene.

"When we pulled up, everyone [was] unsure of what to do," said Riley. All efforts to find Sidney Reso had proved unsuccessful. Riley was told that there were no indications of a struggle or evidence of any kind. The Exxon executive had simply vanished. "I knew the FBI needed to be called," said Riley. He went inside and used the Resos' phone to call the prosecutor. Of this conversation, Riley said, "the prosecutor was hesitant." Chief Riley told the prosecutor, "This guy is the president of the international division of Exxon, there is something wrong here." However, Riley's words fell on cautionary ears. Riley knew his boss didn't want to "hit the panic button." But calling this what it was, in Riley's eyes, was not hitting the panic button. By now, just about everyone realized this was an abduction. Nonetheless, exploratory efforts continued for some time before Riley finally got to make the call to the FBI.

"A call came into our office advising of a missing executive," said FBI special agent Thomas A. Cottone Jr. "We covered all North Jersey and had worked many times with Chief Riley." Cottone headed to the crime scene with Agent Gail Chapman. "I always carried a lot of crime scene equipment," said Cottone. The agent would soon find his equipment to be useful. Thirty minutes later, he and Chapman pulled up to the large estate. Cottone looked around and saw his "good friend" Rich Riley standing in the driveway. "For me," said Cottone, "I'm always thinking crime scene," and so he was glad to see efforts had been made to preserve the scene. Cottone stepped from his vehicle and walked to Rich Riley. After a quick exchange of "how have you been," Riley explained what they had. After looking over the scene, Cottone, Riley and Chapman walked up to the Reso residence.

The home "was big and very beautiful and I met Mrs. Reso to get some basic facts," said Cottone. In the back of the agent's mind was a recent case where a Morris County judge disappeared only to be found with his girlfriend. Could this be what was happening here, he wondered. "That would never happen," Patricia Reso told Cottone. He believed her and could see the sincerity in the grieving woman's eyes. The investigation would soon prove that Sid Reso was not that type of man. After his conversation with Patricia, Cottone went outside to take pictures of the car and to call his supervisor, Special Agent John Walker. It was clear more agents were needed.

Twenty-three miles east, in the FBI office, agents were just receiving word that three of the four LA police officers were found not guilty in the beating of Rodney King. TV stations were reporting that hundreds of people had taken to the streets in protest of this verdict. The verdict even shocked those in law enforcement. One of the agents sitting in the office that day listening to the news was Agent Ed Petersen. Petersen was a tenured veteran of the bureau, and his expertise in kidnappings was well known—he had just authored a comprehensive procedural manual on the subject. The manual was a "what to do" guide needed in these complicated investigations. During the breaking news of the Rodney King beating trial, Ed Petersen was told about the Reso disappearance and assigned to the case.

As a teenager, Ed Petersen wrote J. Edgar Hoover expressing his interest in the elite organization. Once the letter was sent, Petersen spent weeks waiting for Hoover's reply. "I received a letter," said Petersen, "on what it took to become an FBI agent and the things I had to do." This advice became the blueprint for Ed Petersen's life. "All through college," said Petersen, "it was a goal." However, after obtaining his master's degree, Petersen took a teaching position at a local college and put his FBI dreams to rest. Then one day Petersen was asked to participate in a basketball game at the New York Athletic Club, where he met and was befriended and mentored by three FBI agents. In June 1969, Petersen's teenage dream came true, and he was sworn in as an FBI special agent. His career would take him from Tampa, Florida, to Washington, D.C., to New York City. After more than two decades away from his home state, Petersen finally returned to New Jersey. In a recent case, Petersen played a key role in a kidnapping investigation where the wife of a Paterson, New Jersey banker had been taken for ransom. In this case, Petersen and his team were able to bring the wife safely home and secure an arrest with a partial recovery of the ransom money. "I had a pretty good idea," said Petersen, "of how any kidnapping case would fall. I had a checklist to give to anyone who would get any ransom calls." Petersen's manual was a "step by step guide on what [agents] needed to do." Through the years, Petersen worked many kidnapping cases, but the one he was en route to would be the biggest and most troubling of his career.

Kidnappings in the United States are extremely rare, but Reso's position with Exxon International made the possibility of such an occurrence that much more plausible. Petersen said, "We have a good relationship with police officials" in Morris County. His office was "responsible from the George Washington Bridge to the Delaware Water Gap, which includes four counties." It is essential as an agent to communicate effectively, especially

with the number of outside agencies they must work with. Those in law enforcement tend to have strong personalities, which can make it difficult to work with others. This was not the case with Ed Petersen, who had a friendly and welcoming disposition, which made it easy to develop cross-jurisdictional relationships.

It was a forty-minute drive from West Paterson to Jonathan Smith Road, bringing Petersen off the highway and onto a series of gradually narrowing roads. His drive was filled with views of woodlands, open fields with horse farms and rock walls dividing property lines. When he arrived at the foot of Jonathan Smith Road, a uniformed police officer was blocking the entrance. Petersen pulled his car alongside the officer and rolled down his window. The officer looked as Petersen gave him a smile and showed him his gold FBI badge. "Go ahead," said the officer. About halfway up Jonathan Smith Road, Petersen saw the line of police cars. As the agent stepped from his car, he could see several news vans parked nearby and off in the distance. On the grass were several detectives engrossed in conversation. As he walked the driveway toward the Reso home, Petersen glanced at the white car parked at the foot of the driveway.

Entering the large home, Petersen observed Patricia Reso in the living room with several family members gathered around her. In the next room, the agent saw the familiar faces of Chief Rich Riley and Tom Cottone. It was a reunion of odd sorts. Ed Petersen and Tom Cottone had worked many cases together, and many investigations had brought Ed together with Rich Riley. "We didn't know," said Petersen, "if we had a kidnapping [or] if it was an actual abduction." There was no "signs of struggle." The three of them all agreed that every possibility needed to be explored. "Reso did have a history of some health-related issues. You have to obviously look at all contingencies," said Petersen. "Including the possibility of family involvement." This is necessary to "see what [makes] the most sense." With that in mind, Petersen was introduced to Patricia Reso.

"From day one, this was going to be a joint effort," said Cottone. Often family members are involved in missing persons cases. Because of this, it is necessary for investigators to interview relatives of the victim. Riley had spoken with Mrs. Reso. Tom Cottone had spoken with her as well. Both were sensitive and understanding, and it is unlikely Mrs. Reso even realized she was being interviewed. For professionals like Riley, Cottone and now Petersen, the interview takes on a conversational tone. Both men believed there was no family involvement with Reso's disappearance. Now they were waiting to see if Petersen felt the same. As Petersen was speaking with Mrs.

Reso, other investigative efforts were taking place. "In case we got a call," said Cottone, "We started putting recording devices on phones." If this was a kidnapping, a phone call would come.

By this point in time, John Walker, the agent in charge, was on scene. The segmented investigative efforts were now in sequence, and Walker determined that the Reso residence would be the best place for them to run the operation. In collaboration with Rich Riley, Cottone and Petersen began assembling their investigative team. "I was assigned as the case agent," said Cottone, "because it was my county." Ed Petersen was tasked to provide counsel and to assist where needed. Agents Gail Chapman and John Turkington were also assigned to the case. From Riley's side, Tim Quinn and Brian Doig from the Morris County Prosecutor's Office were put on the team for their investigative expertise and familiarity with the local area.

Shortly before sunset, the field searches were halted, and those who conducted neighborhood interviews were brought together to go over their notes. Patricia Reso had graciously offered her basement as the command center, so all gathered over a makeshift table for what would be one of many daily debriefings. In terms of evidence, there was none. As for witnesses, no one seemed to see anything. The technicians reported that

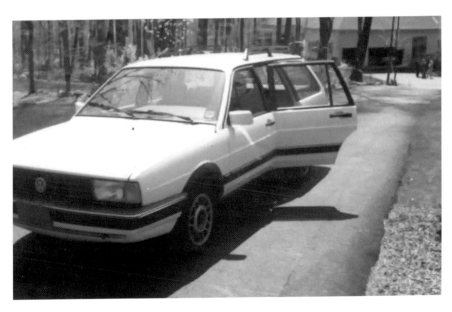

Driver's side door open by investigators. *FBI crime scene photograph.*

the phone lines were wiretapped in case someone should call. Late in the evening, only a handful of law enforcement officials remained in the house with Tom Cottone, Ed Petersen, Rich Riley and John Walker among them. Upstairs, tucked under her sheets, Patricia Reso lay far removed from the world she had once known. Gone was the warmth of her husband lying beside her, and gone was that sense of security. All that remained was insufferable uncertainty.

THE NEXT DAY

THURSDAY, APRIL 30

The sun appeared over the eastern mountains, causing the dark pine needles to glow. Inside the residence, lights began to spring up. Night agents were replaced by fresh faces as investigative team members began to arrive.

The disappearance of Sidney Reso was big news: "Exxon exec missing from New Jersey home," read one paper. The *New York Times* ran an article on page one titled "Exxon Executive Disappears on the Way to Work in New Jersey." The Morris County prosecutor, Michael Murphy, had spoken to the press late in the night, and he was quoted as saying investigators "do not know if it was a voluntary or involuntary disappearance." Thomas Reso, Sidney's cousin, was quoted as saying "[Sid] is one of the most level-headed people I've known in my life....He's not the kind who would pick up and take a fly....We're concerned."

Tom Cottone and John Walker were the first to arrive and immediately began to set the operational agenda of the day. Executives at Exxon had a breakfast platter delivered for law enforcement officials. By 9:00 a.m., the small, makeshift command post was filled with agents and officers. John Walker and Rich Riley gathered their personnel together for the morning briefing.

Under normal circumstances, it is difficult to lead a multiperson, multiagency investigation. Often jurisdictional issues and a clash of

personalities make going slow. However, under the leadership of John Walker and Rich Riley, these obstacles were few and far between. Both men were consummate professionals who ensured that those working for them put their egos aside and did their job to the best of their abilities. "This case grew exponentially from day one," said Tom Cottone. "This was not a one person, one agency case." The investigation involved the Morris County Prosecutor's Office, Morris Township Police and Morris County Sherriff's Department, and many more departments would assist in the following days and weeks to come.

The investigative work was complex but not as much so as organizing the case. For the neighborhood investigation, "We put teams together," said Cottone. The previous day's investigators failed to fully document their findings, so today's team would take formal statements so they could compare neighbors' accounts for possible clues. Officials were also assigned to investigate Exxon's headquarters in Florham Park. The possibility of a disgruntled employee wanting to do harm to Reso could not be ignored. Agents at Exxon were to pull the files of terminated employees who had worked at the Florham Park location as well as those who had personally worked for or had dealings with the Exxon International president.

After these field assignments were deployed, a handful of agents were assigned to explore the possibility of Sidney Reso faking his own disappearance. Pressed in the recesses of the FBI's mind was the case involving British politician John Stonehouse. In November 1974, Stonehouse faked his own kidnapping to avoid financial problems. There was also the 1979 case of Michele Sindona, a powerful financial figure in Italy who faked his own abduction. Sindona was laundering money for the Sicilian mafia and was under investigation when he went missing. A few days after his disappearance, authorities discovered the kidnapping was a hoax. Was Sidney Reso in arrears with debt or in trouble with unsavory business people? Or did he have a girlfriend and left with her? Research into these suppositions needed to be done.

With agents out in the field, Walker, Riley, Cottone and Ed Petersen went over the case. "Why wasn't a note left?" "Why haven't the kidnappers made contact?" It was odd, and these seasoned law enforcement officials had never encountered an incident like this before. If he was abducted, a note left with the car might have prevented the involvement of law enforcement.

Meanwhile, over at Exxon's headquarters, John Turkington and Larry Sparks drove up to the security gate. They were greeted by a security guard, who was friendly and welcoming. After he checked their credentials, he

Reso driveway, location of abduction. *Author's collection.*

provided directions to where they needed to go. The campus had its own road system with black paved drive paths traversing its 268 acres. The landscape was neat and colorful, and a variety of flowers were in bloom. Exxon was a community all its own, with cars driving, pedestrians walking and buildings spread out everywhere—the property looked like a mini metropolis. Exxon was the second largest oil company in the world and the largest petroleum company in the United States. The international division, which Reso presided over, was responsible for $5.6 billion in revenue. Nearly 650 employees filled the grounds here, many of them never having laid eyes on an FBI agent. Today, they would see more than their fair share of agents. The dark-colored unmarked federal vehicle pulled into the parking lot for Sidney Reso's office building. The building was eight or ten stories high with a plate-glass veneer. Inside the large lobby, agents were met by Exxon's security team, who escorted them through the building and up to Sidney Reso's office.

The word of Sidney Reso's disappearance spread quicker than an oil refinery blaze. Whispers could be heard as the agents walked the corridors. Speculation was rampant, and the gossip was worse. Charles Roxburgh was one of many executives who provided insight and helped the investigation along. Roxburgh, like Reso, was a petroleum engineer. His background wasn't all that much different from Reso's. He graduated from the University of Houston in 1963, and his first job was with the Humble Oil Company. Roxburgh's career took him to many locations, such as Houston, Kingsboro, South Texas, New Orleans and overseas in Colombia, Australia, Chile and Hong Kong. "Sid," Roxburgh explained to agents, "was my direct

supervisor." They had worked together in Houston and New Orleans. Roxburgh reported directly to Sidney Reso, and he told agents he had a unique perspective on the man. Yes, he was Reso's subordinate, but he was also a friend. Roxburgh and his wife lived in Morristown, not far from Sid and Patricia's home. The couples often socialized together.

Sitting down with agents, Charlie Roxburgh spoke candidly about his friend. "If you wanted to talk," said Roxburgh, "Sid would listen and give you advice." The concern for his friend's wellbeing could be seen in Roxburgh's eyes when he spoke. "He was a fantastic supervisor. If he saw a flaw in your idea, he'd tell you about it but didn't micromanage you." The scope and depth of Reso's position and responsibilities surprised the investigators. "Sid had a very large job and did it pretty well too," Roxburgh explained. As president of Exxon International, Sidney Reso oversaw "upstream" operations outside the United States and Canada. Upstream, in the energy industry, refers to the exploration or drilling for underground or underwater reserves of crude oil or natural gas. Operations in the Middle East, Southeast Asia, Australia and Malesia all reported to Reso. "All the functional departments outside of the United States report to Sid," Roxburgh explained. This included some downstream operations such as refining and marketing. "Despite his high position," Roxburgh said, "I don't know of anyone that disliked Sid. He was very friendly, very nice and would always be ready to help anyone." It was abundantly clear that Sidney Reso was a high-value executive, making him a prime candidate for a kidnapping. Investigators learned that the executive was paid a salary of approximately half a million a year.

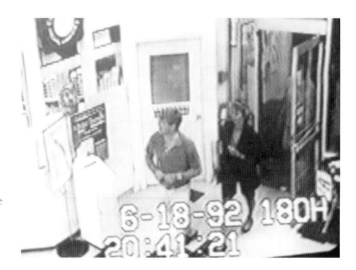

Kidnappers in store getting supplies. *Provided by Morris County police officer Steve Foley.*

Assisting with the investigation at Exxon were several local detectives and police officers. Each went from office to office interviewing executives and workers about Sidney Reso. These interviews bore out the fact that Sidney Reso was well liked and respected by just about everyone at Exxon. From high-ranking executives down to the secretaries, all sang the praise of the international division president.

Digging into Reso's personal side to explore the previously discussed suppositions, investigators quickly realized that Reso had no substantial debt, was not aligned with any inappropriate business transactions and was a loving husband and father who would never leave his wife and family. He was a wealthy man, settled and comfortable with his status in life. Simply put, by more than one of the people interviewed, Sidney Reso was not someone who would fake his own disappearance. What investigators did discover was a pattern of systematic behavior by the executive. Reso, they learned, was a creature of habit. He liked to do the same thing day in and day out. This, investigators realized, left Sidney Reso vulnerable to being abducted.

RANSOM REQUEST

By ten in the morning, the phone had rung numerous times with well-wishers, concerned friends and family members wanting to lend support. Everyone within the Reso home was on edge. Meanwhile, over at Exxon, phones lines were inundated with callers. However, the energy company refused to speak with the media—or anyone else for that matter—about Sidney Reso. "It's our practice," said Exxon spokesman Jim Morakis, "not to give any information on a person's family life or that kind of thing for security reasons." A different kind of caller rang the Exxon line at 10:13 a.m. The voice of the caller was scratchy but appeared to be that of a female. Her message was short: "Information regarding Sidney Reso can be found at the Livingston Mall."

John Turkington and Larry Sparks—who were at Exxon when the call came in—responded immediately to the mall. The Livingston Mall is not far from Exxon's Florham Park location. The rather large indoor shopping center is frequented by people from throughout Morris County and the surrounding communities. Macy's, Sears and a host of other stores fill the large space. The parking lots surrounding the large mall occupy acres of property. Dressed very much like G-men, Turkington and Sparks combed the mall parking lots looking for that piece of information the caller had spoken of.

The day was young, and the temperature was already creeping towards the mid-seventies, with a bright blue sky above. The weather brought droves of people out of their homes, with many heading towards the Livingston

Mall. The caller simply said, "Information regarding Sidney Reso would be found." What that meant was a mystery. Hopefully, as they searched the lots, they would recognize what that piece of information was. Then, while driving through the first parking lot the two agents spotted something unusual. "Inside of a yellow guardrail which surrounded a telephone pole in the middle of the parking lot," said John Turkington "was a white envelope" attached to the telephone pole. John Turkington stepped from his car, trying very hard to look not like an FBI agent but rather an Exxon executive. As Turkington was retrieving the envelope, Sparks scanned the lot to see if anyone was watching. Pulling the envelope free from the pole, Turkington noticed the package was addressed to "Mr. Lawrence Rawl, Chairperson, EXXON COPRORATION." Glancing inside, he saw "a typed one-page document and Exxon credit card." The envelope was brought back to the command center and carefully opened so as not to destroy any forensic evidence it might contain. When the credit card was removed, investigators could see it was Sidney Reso's.

Inside the command center, with agents and investigators huddled around, the letter was read aloud:

> The major industrial entities continue their thoughtless programs which are destroying the earth and harming countless forms of life. Destruction of the land sea and air continues at unprecedented rates. World organizations and governmental bodies have so far proven themselves totally ineffective in preventing these activities.
>
> The various societies and organizations that support environmental concerns have expended varying degrees of effort to educate the populace and stop these policies but much remains to be done. We recognize that it will require a long and costly struggle to overcome the power and influence that your size and money provides.
>
> We propose to make industry pay for this continuing campaign. To ensure your contribution we have seized the President of your International Division.
>
> Our research, based upon your previous payments and other factors indicates that your share will be $18.5 million.
>
> Gather the money in used $100 bills.
>
> Obtain a portable cellular telephone with a 201 area code.
>
> Place an ad in the Star Ledger Pets column under Birds saying "Rare International birds—call 201-XXX-XXXX" using the cellular telephone number with the last 4 digits reversed.
>
> We will contact you with delivery instructions.

Mr Reso will be held in total isolation with no food or water. If you do not fully comply he will most certainly die. We have observed and developed information on many of your personnel. If we do not hear from you we will sieze [sic] another of your employees.

Prior to your delivery of the money we will demonstrate that Mr. Reso is still alive. He will be released after the delivery has been safely accomplished.

Any involvement by the police, FBI or media will be extremely counterproductive. We will not negotiate these demands.

The letter was signed "Fernando Pereira Brigade, Warriors of the Rainbow." Everyone in the room was puzzled. No one had ever heard of such an organization. The ransom of $18.5 million was immense, and investigators would soon find that it was the largest ransom request made in the United States. "We knew we could dissect that letter," said Ed Petersen. "Doing so would bring us a little closer to who would be responsible for this kidnapping." Several people in the room were trained in forensic writing analysis, including case agent Tom Cottone. "To read the letter, maybe this is legit," Cottone thought. "It was after the *Exxon Valdez* [and] when I was in NY I worked the Puerto Rican terrorist group [FLN] case." In that case, the communications happened like what the kidnappers were requesting. "On the face of it," said Cottone, "it sounded like…an ecoterrorism group."

Obtaining a cell phone was first on the agency's agenda. Cell phone technology was reasonably new and not in wide use. Once they secured the twelve-inch-long cellular phone, an agent made a call to the *Star-Ledger* to place the ad. The ad simply read, "International Rare Birds 201-404-6713."

By midafternoon, nearly fifty agents and law enforcement personnel were assigned to the case. "We were setting up the command post," said Tom Cottone. In addition to law enforcement, a number of Exxon's security personnel were on property to assist.

The Reso basement was spacious and allowed for a comfortable gathering of law enforcement personnel. The letter, envelope, credit card and duct tape that held it to the telephone pole were placed in evidence bags, labeled and then flown to the FBI lab in Virginia by the Exxon corporate jet. There, a forensic analysis of the evidence would be conducted. Trace evidence is often left behind, regardless of the efforts of perpetrators to conceal who they are or link information back to them. Walker and his team were hoping something in the evidence they sealed up and flew off would help break the case.

Federal and local authorities were working side by side with Exxon representatives who were sent to provide whatever assistance they could. Often, this was opening doors into the very closed environment of Exxon. Two of the executives helping most were Charles Roxburgh and Jim Morakis, the media spokesman for Exxon. Through this collaboration, investigators learned of the threats that existed against some of the company's executives. Kidnapping was a major concern for Exxon, especially for its executives who traveled overseas. However, agents were told, the precautions taken in foreign travel were not instituted on American soil. There was a pervasive ignorance to the fact that kidnappings—although unlikely—can occur within the United States.

Agents were familiar with abductions that happened during the 1980s involving several American businessmen. Most of these cases didn't get wide press coverage, mainly because companies wished to keep these matters confidential and out of the news. Reports of executives being abducted is simply not good for shareholder stocks. Those occurring abroad mostly take place in countries where law enforcement is poor or corrupt, forcing companies to deal directly with kidnappers.

In the underbelly of the Reso home, sitting amongst John Walker, Tom Cottone and Ed Petersen, Jim Morakis spoke of a pleasant day in Buenos Aires in 1973 when Victor Samuelson, a business manager for Exxon, was kidnapped. Samuelson was with several Exxon employees at a private club showing them the grounds when he was abducted at gunpoint by a group of men. After five days of not knowing what happened to Samuelson, an ad appeared in the People's Revolutionary Army newspaper outlining the demands of the kidnappers: "Exxon [needed to] admit it was an imperialist exploiter" and, as penalty for its sins, must ante up $10 million in $100 denominations. Needless to say, the similarity to the recently received letter did not go unnoticed. When agents asked about the outcome of the case, they were told it took 144 days to be resolved, with Exxon paying a ransom of $14.5 million in $100 denominations.

This case, agents were told, taught Exxon a valuable lesson. The Exxon board was slow to respond to negotiation attempts, and because the board failed to meet the kidnapper's timeline, Samuelson was scheduled to be executed. If not for an unauthorized call by an overzealous kidnapper fifteen minutes before Samuelson was to be shot, Samuelson would have been killed. After the ransom money was received by the kidnappers, they returned Victor Samuelson in a wooden box on April 29, 1974. It could not have been a coincidence that Sidney Reso was kidnapped on the anniversary

of Samuelson's return. Sadly, this incident foreshadowed Sidney Reso's fate. Based on the similarities in the case, investigators could not ignore the strong possibility that an international environmental group might be responsible for Reso's disappearance.

The Samuelson case attracted international attention and demonstrated to those wishing to capitalize on abduction and extortion that Exxon was willing to pay an extraordinary amount of money for its people. If Exxon paid that much for a manager, what would it pay for the president of Exxon International?

Charles Roxburgh picked up the phone, dialed corporate headquarters, and advised CEO Lawrence Rawl of the kidnapper's ransom demand. Rawl called the Exxon board, which immediately took decisive action and authorized the release of the money. Arrangements were made to withdraw the $18.5 million and transport it to the command post. This was an operation in and of itself, requiring advanced surveillance teams and SWAT members. Under intense police supervision, the money was brought to the Reso home and stored in the basement closet. John Walker had a security camera installed to watch the door, and Rich Riley assigned armed officers to work shifts around the clock to ensure the safety of the money. "Steve," Chief Riley said, speaking to Detective Steve Foley of his office, "I'm looking for someone to work overnight to watch the money." Several years had passed since Foley worked the overnight shift, but he knew he couldn't refuse the assignment.

It was an easy detail for the seasoned detective, and he likely hoped for a bigger role in the operation, but for now, he had to do what he was told. Each night, Foley would arrive at the command post at a quarter to twelve and meet with FBI agent John Farrow, who was also assigned to protect the money during the night shift. Walker and Riley wanted checks and balances, and each could keep an eye on the other. When you're dealing with $18.5 million, all precautions must be taken. "John and I would come in at night and eat the leftovers from the Exxon food delivery. It was an easy job, just make sure the money didn't go anywhere." With the money secured and properly protected, the FBI started to develop a dossier on Sidney Reso and the company he worked for—a standard practice in these types of investigations.

Sidney Reso's disappearance was dubbed by the FBI "Operation SIDNAP." When the dossier was finished and placed into words, it read like a history lesson rather than a police report.

Exxon Corporation was a company that dated back to the Industrial Revolution with a complicated past of mergers, acquisitions and takeovers.

A distraught woman. *From the Star-Ledger.*

The origins of the company begin with John D. Rockefeller's Standard Oil, which was formed in 1870. During the late nineteenth and early twentieth centuries, Standard Oil dominated America's energy industry, creating what was deemed a monopoly. In 1911, the U.S. Supreme Court ordered the company broken up. Out of this court order came thirty-four different oil companies, with one being Standard Oil of New Jersey. Eventually, Standard Oil of New Jersey would become what we know now as Exxon.

In the years prior to the name change, Standard Oil of New Jersey demonstrated intense innovation within the energy field. In 1936, the first "cat-cracking" refinery began operations in Paulsboro, New Jersey. This fostered a new process using a clay-like catalyst to boost gasoline yields and octane. A decade later, four developers from the newly named Jersey Standard created a fluid catalytic cracker process that became the standard for cracking. By the 1980s, under the Exxon Corporation brand, a facility was dedicated specifically for developing environmental health alternatives for the way Exxon operated. Resulting from this was 3-D microtomography, which allowed researchers to study opaque objects without damaging them.

Notwithstanding these environmental efforts, the company's reputation had recently been damaged by the *Exxon Valdez* oil spill. The investigation into the spill revealed the *Exxon Valdez* departed the Trans-Alaska Pipeline terminal at half past nine on March 23, 1989. Captain Joseph Hazelwood was in the wheelhouse, and William Murphy, a harbor pilot, was maneuvering the ship through the Valdez Narrows. Murphy was hired exclusively for navigating the large vessel through the narrows of the Prince William Sound between mainland Alaska and the Kenai Peninsula. The narrows are a small entrance point into the port where ships have to navigate around Bligh Reef. After Murphy navigated the *Valdez* past the narrows, he left the wheelhouse, leaving the less-skilled Captain Hazelwood in charge.

With temperatures lingering at nineteen degrees, the Alaskan waters had floating icebergs, and the *Valdez* encountered one floating directly ahead of it. In response to this, Hazelwood ordered the vessel out of the shipping

lanes and then reportedly left the wheelhouse, leaving his helmsman in charge. The 984-foot-long vessel carrying 1.48 million barrels of oil was a moving disaster. Murphy had maneuvered the vessel out of harm's way before leaving the wheelhouse, but with Hazelwood's order to leave the shipping lanes, the large *Valdez* was on a trajectory to strike the Bligh Reef.

Initial speculation into the incident suggested that the helmsman fell asleep due to a lack of rotation by the captain. Other criticism blamed the accident on Captain Hazelwood for leaving the wheelhouse. The accident caused approximately eleven million gallons of oil to leak into the sound, impacting nearly 1,300 miles of shoreline. The cleanup operation was complicated and, three years later, was still ongoing.

In 1990, the National Transportation Safety Board's investigative report found that Exxon was partially responsible for the accident due to its lack of oversite. The investigation revealed that crew members were overworked and fatigued due to a poor work schedule and that Captain Hazelwood was negligent for leaving the wheelhouse and not navigating the *Valdez* as he was ordered to do. The findings validated some environmental groups' concerns and fueled many fanatical environmental groups against the Exxon Corporation.

With all the research agents had gathered on the energy company and activist environmental groups, they were still not able to obtain any information about the Fernando Pereira Brigade or the Warriors of the Rainbow. Even organizations such as Greenpeace had advised that they had never heard of such an organization. Agents did learn, however, that Fernando Pereira was a Dutch photographer who was killed on board the vessel *Rainbow Warrior*, which, as it turned out, was a Greenpeace ship. The *Rainbow Warrior* was moored at the Marsden Wharf in Auckland, New Zealand, when it exploded after French secret agents attached two bombs to the hull. The blast killed Pereira. This information suggested a new group could have been formed and was now holding Sidney Reso.

"AN ASSUMPTION OF FOUL PLAY"

FRIDAY, MAY 1

The blue sky had lingering scattered clouds above the dark green Morris pines, and the warm spring weather was a much-welcomed occurrence, especially after the brutally cold and long winter that had befallen the area. As families in the region were looking forward to a pleasant weekend, Patricia Reso and her children were living a nightmare. Ed Petersen woke heavy-hearted. He had spent a considerable time with Patricia Reso and her children and couldn't help feeling a deep sense of sadness. He knew this kind of heartache himself. As a teenager, he had lost his father. He hoped the Reso children wouldn't have to go through that ordeal. Law enforcement officials are taught to distance themselves from their emotions and focus on the task at hand. However, this isn't easy, especially when so much time is spent with the victim's family.

Over the aroma of brewed coffee, the primary investigative team working the case gathered in the command post. The day's activities were being discussed and decisions were being made on who was going to do what. Ed Petersen would spend the day with Jim Morakis, Exxon's media representative. Petersen would pose as Morakis during talks with the kidnappers. Authorities didn't know when the call would come, but the ad was in the morning paper, so it was just a matter of time.

Outside of the Reso home, several men wearing white overalls and white helmets under the guise of being the telephone company were climbing the

Reso's briefcase and overcoat. *FBI crime scene photograph.*

telephone poles. They would work several hours in front of 15 Jonathan Smith Road bringing additional phone lines into the command post. John Walker would supervise the setup of the command post, while Tom Cottone, the case agent, coordinated the investigative efforts and reported these back to Walker for review and approval. Chief Riley assigned Tim Quinn of the Morristown Police and Brian Doig from his office to assist FBI agents in the field.

Exxon executives provided breakfast, lunch and dinner to those working at the command post. They would do so throughout the entire duration of the operation. How long that would be no one knew. After lunch, additional members of the Reso family started to arrive. Patricia's children flew in from San Francisco, St. Louis, Washington and Houston. Sidney's cousin Jerome Reso, an attorney from New Orleans, arrived and became the family's media representative. A short time later, Jerome put out a statement saying the Reso family was keeping the news from Sidney's mother, who was "seriously ill." In his statement, Jerome said Reso was a "genuine, nice guy." He said it was "hard to find the right adjectives to describe someone" like Sidney Reso. As anticipated, the press was relentless in its efforts to get information on the case. The Morris County prosecutor,

Michael Murphy, gave just a brief statement, saying "The investigation is being classified as a missing persons matter."

The day was slow moving with anticipation of the call from those who had Reso. Tracing capabilities and recording devices were ready to go, with technicians testing the equipment throughout the day. What was once a furnished basement was now a hotbed of activity with wires and phones ringing. There was still a lot of work that needed to be done prior to the money exchange. The plan for the ransom transaction was to have a shadow team surveil the vehicle carrying the money. There would be agents in the car with the money, which was dubbed the "money car." Exxon's board asked the FBI not to worry about recovering the money but rather to focus on giving the kidnappers the money for Sidney Reso's safe return back to his family.

Carrying a payload of $18.5 million was obviously a concern. There was a real possibility the kidnappers could ambush the car. The FBI wanted the kidnappers to believe that only Exxon personnel were in the car, but doing so would increase the likelihood of an ambush. To mitigate this threat, FBI SWAT agents were brought in for the operation. There would be multiple SWAT teams out in the field floating in and around the money car as it proceeded to the drop location. Moreover, a SWAT agent with a fully loaded automatic weapon would be tucked in the back of the car driven by Ed Petersen, and Tom Cottone would ride shotgun.

According to the kidnap letter, the abductors planned to communicate by cell phone, which was new technology at the time. It was decided that when a call came in, either Cottone or the SWAT agent would radio into the command post that the kidnappers were calling. This would allow SWAT agents in the field to get in place before the money car arrived. Once the money car was mobile, a shadow car would follow it. This was deemed a recovery operation, and if officials weren't sure what that meant, John Walker made it known the objective was to get Sidney Reso back, not to make an arrest. A great deal of preparation was needed for this operation. Cars needed to be fueled, weapons loaded, additional ammunition secured, radios tested and manpower shifts filled along with a host of other support functions crucial to ensuring a safe money exchange.

The sun had set behind the dark hills, and many of the nonessential support staff had completed their tasks and were gone. Only a few agents were left inside the command center. The day was terribly troubling for the Reso family. Waiting and hoping for the kidnappers to call drained everyone, including the law enforcement officials. The worry for Patricia was due to her

Patricia speaking to the news media. *From the* Star-Ledger.

husband's health. He wasn't a sick man, but he wasn't a heathy one either. His prior heart attack and history of high blood pressure was a concern. She worried tremendously about his wellbeing. The heartache she and her family felt could not be imagined.

The large black cell phone laying on the command post table rang at 9:30 p.m. Silence filled the room as Ed Petersen walked to answer the call. "This is it!" Petersen looked over at the wiretap technician to see if he was ready. "Jim Morakis," Petersen said. The caller was a male and in a monotone voice said, "Go to the entrance of the Lewis Morris Park to pick up instructions." The call was then dropped.

The call was recorded, and the number was trapped and traced. The trace revealed that the call was from a payphone at the intersection of Routes 202 and 206 in Bedminster, New Jersey. This location was some twenty miles from the Reso residence. Bedminster police were called and asked to respond passively to the location and see if they could spot the caller. When the Bedminster police officers arrived, they didn't see anyone or any vehicles. The phone booth was kept isolated, and when agents were sure the booth wasn't under surveillance by the kidnappers, crime scene investigators processed the booth for forensic evidence.

After a discussion on how they should approach the kidnappers' demands, officials determined the call wasn't a request for a money exchange. Based on this assessment, Ed Petersen and Rich Riley left the command post to recover the note. Ed Petersen wasn't familiar with the area, so Chief Riley said he would drive him to the location. The park was in an isolated section of town off the Mendham Road. The two were apprehensive, considering the kidnappers believed they were corresponding with Exxon officials and Jim Morakis in particular. Morakis was the high-profile spokesperson for the

energy company, and taking him hostage would increase their bargaining chip without a doubt. Could this environmental group be so bold as to try and abduct Morakis? The two pondered this as Riley turned the vehicle onto the dirt-road entrance to Lewis Morris Park.

The driveway was blocked about twenty feet in by a gate. As a lifelong resident of Morris County, Riley knew the park well. He had been there many times himself enjoying the history it held as the oldest park in Morris County. The time was a little after ten, and it was pitch dark. Petersen stepped out of the car and began looking for the note. The tension could be cut with a knife. As Petersen turned his flashlight in a 360-degree motion to check the surrounding area, Riley sat in the driver's seat ready to get them out of there if needed. The caller said the instructions were near the entrance. The note wasn't easy to find, but Petersen eventually spotted it in the moist grass near the park's wooden sign. Safely back inside the car, Petersen read the letter aloud. "Delivery of money," the letter read, "in 10 Eddie Bauer large sport duffle bags." The two men looked at each other a bit puzzled. Why Eddie Bauer designer bags? Petersen resumed reading. "To be delivered by Mrs. Reso and children using Reso family station wagon." The letter concluded with the signoff "Warriors of the Rainbow."

When the two arrived back at the Reso command post, Walker and Cottone were listening to the male caller's recorded voice. They could tell it was a prerecorded message. They thought the voice could have been Sidney Reso's and asked Patricia to listen to the recording. After listening to it several times, Patricia and her children didn't believe the voice was Sid's. Chief Rich Riley, on the other hand, disagreed and believed the voice was Reso's, even though he had never heard Sid Reso speak. "I could hear the fear in this guy's voice," Riley explained. In his long career, Riley spent years in the wiretap business. You get "a taste for what's required of a listener," he says. There is more to it than just familiarity with a voice. There are other indicators, such as phraseology, inflection and tension. The voice on the recording, according to Riley, was under a great degree of stress. Despite this lawman's opinion, without voice verification from family members, agents were left wondering whose voice that was.

The tape was cataloged, placed in an evidence bag, and sent to FBI headquarters, where voice experts would conduct comparisons of the known recorded voice of Sidney Reso family members had provided. This, along with the envelope and note was flown via an Exxon jet to Quantico, Virginia. There the envelope and note would be analyzed for trace evidence.

The case made national attention. *From the* Star-Ledger.

Based on the requests in the note, it was clear the kidnappers would not be making further contact this night. Time was needed to comply with the request. The command post thinned to just a few officials. Ed Petersen was one of the last to leave and arrived home just after midnight. His house was dark and quiet, and he paused momentarily to enjoy the solitude. The day taxed him physically and mentally. He thought of his family safe and sound asleep and said a prayer for the Reso family. He needed to get some sleep, for in only a few hours, he was needed back in the command post.

SATURDAY, MAY 2

The stretch of nice weather continued, and the forecast was projected to be in the mid- to high seventies throughout the day. Gathered inside the command post drinking coffee and eating the Exxon breakfast of muffins,

bagels and fresh fruit was the investigative team. The nourishment would be needed, because this was going to be a long day, and a lot of stuff needed to get done. John Walker and Tom Cottone conducted the morning briefing with an unusual investigative assignment: someone needed to go shopping for ten Eddie Bauer bags. Rich Riley said he would continue to schedule around-the-clock coverage for protecting the money. Moreover, he assigned the various police officers to assist agents in the field with their investigations. And Ed Petersen would spend the day with Jim Morakis learning all he could about him and Exxon.

A little after eleven, the Eddie Bauer bags were brought into the command post, and under the supervision of Chief Riley, the money was taken out of the closet and placed into the duffle bags. The transfer was tedious and took a good portion of the day. Surprisingly, the $18.5 million divided into $100 bills fit perfectly into the ten bags. It was clear the kidnappers had done their research.

After additional deliberations, it was decided a nine-passenger jump-capable plane would be used in the operation. A crew was selected for the air surveillance, which would include sophisticated audio and video surveillance. The kidnappers made it a point to say that the Reso family station wagon was to be used, so agents treated the roof of the car with an invisible liquid that could be seen through special binoculars. A plane wasn't as mobile as a helicopter, but it was quieter and would mitigate any chance of being spotted. There was a strong concern about the kidnappers conducting countersurveillance. In all, the operation would consist of fifty agents and law enforcement officials. They would be assigned to work in groups of two and would be positioned at various points throughout Morris County.

It was less than seventy-two hours since Sidney Reso went missing, but in that time, officials were able to build a chronological outline of all of the executive's travels. In doing so, the hope was to find a connection between his travels and his abduction. Moreover, officials were digging deep into Reso's associates, both business and personal, to try and find a lead. "We went back five years," said Cottone about considering disgruntled employees. "We were working our way through those files." Once the names of terminated employees were compiled, criminal history and financial checks were conducted. People with financial problems and a criminal record would rise to the top of the list and be scrutinized closely.

The news of the missing executive spread like wildfire and garnered national coverage. Despite the pressure from the media for more information,

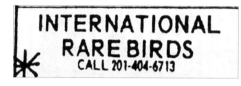

Ad placed in paper to communicate with kidnappers. *From the* New York Times *Classifieds.*

the prosecutor's office would only say the investigation was "on-going and was being handled as a missing-persons case." The lack of information left journalists filling their columns with security experts speculating on what was unfolding behind the scenes. "It sure looks like somebody grabbed him," said one expert. Another expert was quoted as saying, "Executives do not receive any training in avoiding kidnappers." Another article quoted a nameless Exxon representative who said, "Executives who travel often let down their guard after they return home…[and] tend to be lulled a little bit into complacency." Although little information was provided to the press, a *Star-Ledger* piece was spot-on when it said, "When an executive is kidnapped, its usually because he has rejected protection."

SUNDAY, MAY 3

Sunday morning was clear and crisp with little traffic on the Morris County roads as agents drove to their assignment on Jonathan Smith Road. It was unlikely a money exchange would be requested during the day, which meant another day of waiting—and for Patricia and her children, another day of heartache.

When dusk set, it brought increased anticipation and an influx of radio and phone communication positioning agents and law enforcement personnel who were spread throughout the Morris County area. For the next few hours, the command post was reasonably quiet, with no one really talking. Ed Petersen sat off in the distance going over in his mind the life of Jim Morakis. John Walker and Tom Cottone were reviewing the operations plan and double checking to make sure they didn't miss anything. Rich Riley was ensuring his people were in place for the night's operation.

At 10:00 p.m., the cell phone rang. The caller was short and direct with his message: "Respond to the phone booth at the Villa Restaurant, Summit, New Jersey, to await further contact." The technicians were able to trap the call and trace it to the Terrace Exxon Service Station, which they realized was directly across the street from the restaurant. John

Walker radioed the operatives in the field and positioned those nearby in line of sight of the restaurant's phone booth. However, when officials arrived, they saw no sign of the kidnappers. Within twenty minutes, the surveillance plane was over the restaurant. In that twenty minutes, Rich Riley and his crew had loaded the ten duffle bags filled with the cash into the backseat of the Reso car.

Ed Petersen and Tom Cottone went over their roles, and the SWAT agent readied his gear and took a position in the back of the car. "I had my MP-5 submachine gun," Cottone said, along with his service weapon strapped to his hip. Ed Petersen strapped his service weapon around his waist. It took a while to navigate the winding country roads en route to the restaurant. As they entered Summit and closed on the location, they could see Villa Restaurant sitting on the corner of River Road and Miele Place. "Ed backed the car into a spot right in front of the two phone booths," Cottone said.

At the time, phone booths were very common; today, not so much so. The booth was constructed of an aluminum frame with waist-high red panels on the back and two sides. Above these panels were two glass panes. The folding door into the booth had glass panes from ground to ceiling, with the design allowing for a full line of sight if anyone was looking. It was a strategically good position for the kidnappers to place someone. It also gave the impression they were watching. The agents knew this and handled themselves accordingly. For Petersen, who was portraying Morakis, it was unnerving, for he knew he was an easy target. "We waited and waited," said Cottone, who was keeping a close eye on Petersen only a few feet away. The warm weather had cooled into a chilling night, especially for someone spending his time standing in an aluminum phonebooth.

Radio communication from agents and police personnel in the field indicated that there were no signs of suspicious activity or vehicles. If there was any relief, for Petersen, the location was not an advantageous one for an ambush. It was well lighted and in the middle of Summit. Still, with $18.5 million in the back of the car, tensions were high.

For Cottone and the agent stretched out in the back of the car, the wait was just as agonizing. They sat for hours waiting for the phone in the booth to sound. In that time, Cottone couldn't help but notice the bright Exxon gas station sign across the street. How ironic! Or was it? After "several hours," Cottone said he could hear "the phone across the street at the Exxon gas station started to ring." Cottone yelled over to Petersen that the phone was ringing, which sent Petersen scurrying across the two-lane road

to get to the phone. However, when he got there, the ringing had stopped. Petersen shrugged his shoulders and walked back across the street and into the Villa's phonebooth.

"We waited four hours longer," said Cottone. Field personnel combed the streets, writing down plate numbers of vehicles they deemed suspicious, but nothing would ever come from any of the plate look-ups. The night's detail was concluded, leaving everyone a bit mystified as to what had happened. And they were a little concerned the abductors may have noticed one of their law enforcement officials in the area.

MOTHER`S DAY

SUNDAY, MAY 10

Seven days had passed since the ransom night failure without any form of communication from the kidnappers. Interestingly, a landscaper cutting grass outside the Villa's Restaurant found a letter in the bushes. Apparently, the kidnappers had planted it there. An analysis revealed that it was a legitimate letter and not a hoax. The letter provided instructions to drive to the Summit train station and await further instructions. This prompted agents to search the train station. They discovered a tape recording duct taped under the phonebook shelf.

The tape was brought to the Reso residence and played for Mrs. Reso. The voice on the tape was a male saying, "I want to come home." As part of the message, the male mentioned the LA riots and reiterated "I'm looking forward to coming home." However, Mrs. Reso said the voice was not Sid's. Agents played the recording so Charlie Roxburgh could hear it. He, too, couldn't say the voice was that of his friend. Considering this, "We didn't know if he was alive or not," recalled Cottone. If he was alive, why wasn't it his voice?

Something about the letter bothered Tom Cottone. It took a while and a few readings of the letter before he figured out what it was—"It was the verbiage," Cottone thought. The letter said, "Pull out of the restaurant and make a prohibited left turn. Who would use that term? That's something

you put on a ticket for a moving violation." Could the kidnapper be a cop? Cottone thought it was a strong possibility.

Most of Exxon's security staff were former law enforcement. Could this be an inside job? Agents weren't taking any chances and were looking at everyone, including those who were still working in the security department. For some, this was uncomfortable. For others, they knew it was the right course of action. During their investigation, it was discovered that a former employee had a prior criminal record. When the case jacket was pulled, it was found that Chief Rich Riley had been the arresting officer. They soon took him off the list when another employee popped up as a possible suspect. This man had financial troubles and a minor criminal charge in his background. "The poor guy," said Rich Riley, "was put through hell." Cottone was quick to say, "This was at a time before the internet and Google," meaning all the research conducted, including that on the Fernando Pereira Brigade and the Warriors of the Rainbow, was done by old-fashioned police work. Despite all the manpower they had on the case, authorities were not any closer to solving the crime.

If Patricia Reso was reading the articles being written in the Sunday newspapers, she certainly noticed that what she was told by authorities and what authorities were telling the media conflicted. "The Morris County Prosecutor's Office is the lead agency," Prosecutor Michael Murphy told the papers. "The case is a missing person case." In reality, Murphy and the FBI wanted to keep information about the case under wraps. Part of this strategy was to force the kidnappers to reestablish contact.

The attempts to keep information about the case silent, however, were in vain. Someone leaked information to the press, as illustrated by the *New York Post* headline only four days after the failed ransom night: "Did Eco-Terrorists Seize Exxon Exec in N.J.?" The article reported that an environmental group called Rainbow Warriors was claiming responsibility. Another newspaper's headline read, "Ransom Note Revealed for Exxon Official." The latter article went further in revealing confidential information by saying cryptic communications centering around classified ads were taking place between the FBI and the kidnappers. To John Walker, it was clear he had a problem. This confidential information making it to the papers was an embarrassment, but more important than that, it could endanger the life of Sidney Reso. Something needed to be done.

As might be expected, a flurry of questions came in from the media, forcing the prosecutor's office on late Sunday afternoon to advise the press that the prosecutor would be making a formal statement early on Monday

morning. Positioned on the steps of the historic Morris County Courthouse, with its beautiful redbrick facade and large white cupola, was a wooden podium with the Morris County seal shinning in the morning sun. Gathered on the concrete sidewalk and on the large grass frontage of the courthouse were scores of news reporters and spectators waiting to hear what the prosecutor had to say. Wearing a dark suit with a red tie, Michael Murphy stepped from the large white doors in front of the courthouse and slowly walked to the podium.

As you know a New York city daily newspaper has printed unconfirmed allegations regarding communications from a group maintaining that they have Mr. Reso in their custody. It would be inappropriate for this office to discuss this report of a communication in the absences of verification that the communication is indeed from an individual or group holding Mr. Reso in custody. Absent a current photograph or voice recording this office cannot reach the conclusion that Mr. Reso is in the custody of any particular group. It is the desire of all parties that Mr. Reso be returned unharmed in an expeditious fashion.

If those in the audience believed Murphy was speaking only to them, this couldn't have been further from the truth. With no contact from the kidnappers and Sidney Reso still missing, Murphy was hoping Reso's captors were listening.

The news that an Exxon executive was missing was becoming national news. "Vanished," read one newspaper headline. The cover of the *New York Daily News* had Sidney Reso's picture with the word "Missing" across his image. Even though the media had little information, its coverage was spot on—Reso was gone, likely a victim of a kidnapping, and the FBI had little to go on.

The neighborhood interviews did provide an interesting piece of information. One neighbor said that the morning Reso went missing, she noticed a woman jogging on Jonathan Smith Road she had never seen before. The state police composite sketch bureau was notified, and a drawing of the woman was created. The sketch depicts an attractive woman with strong facial features and long, thin eyebrows who appears to be in her early to late forties. This wasn't much, but a flyer was sent out in the hopes someone would recognize the woman.

Meanwhile, each passing day brought speculation as to what had happened to Sidney Reso. The papers continued their coverage, which

FBI case file on Major Case #57, "SIDNAP." *Provided by Chief Rich Riley.*

now included interviews with security experts and Morris County residents. One college student speculated that Sidney Reso was "sitting on a beach in the Cayman Islands drinking margaritas," while other county residents suggested Reso "staged his disappearance." The insensitivity of the media coverage is highlighted by a cartoon sketch of Sidney Reso bound and gagged in a chair at gunpoint by oil-soaked birds, an obvious correlation

between Reso and the *Exxon Valdez* oil spill. This article infuriated executives at Exxon, prompting a formal letter of complaint to the editor of the *New York Post*, who published the depiction:

> *For those of us who know Sid Reso, the missing Exxon executive, your "cartoon" on Page Six of the May 11 edition is particularly shocking and painful. This shameful attempt to create humor from the disappearance of a decent and honorable man, with all the contingent pain and stress it has caused his family, friends, and most civilized persons who have followed this situation, sets a new low standard for journalistic treatment of such abhorrent events.*

In response to the news reports of an environmental activist group possibly involved with the disappearance, the environmental group Greenpeace released a statement: "For 20 years Greenpeace has steadfastly adhered to the principle of nonviolence. This tragic allegation does a real disservice to legitimate environmental organizations working to protect our global environment."

The local papers issued warnings to residents telling their readers "to take extra security precautions." Through all this coverage, Patricia Reso gave few if any statements to the press. However, with the widespread speculation and insensitivity taking place, she decided to meet with the press.

Sitting at a table inside a Morris Township elementary school, she looked shaken but resolute. "Her clear blue eyes," wrote Dory Devlin of the *Star-Ledger*, "looked somewhat weary as she expressed anxiety over not knowing her husband's circumstances." She wore a dress with a blue ribbon on it; the ribbon was given by an Exxon employee to honor her husband. Everyone at Exxon was wearing the same type of ribbon for Sidney. Called by the *Star-Ledger* a "Mother's Day plea," Patricia spoke softly of her family and what they were going through. "As things unfold," she said, "I have to take them minute to minute, hour to hour, day to day." Silence filled the large room, which was crowded with journalists and TV news crews. While she spoke of her life and relationship with Sid and the love they shared, not a dry eye could be found in the large space. Then she spoke of her worry; "My primary concern is his safety and return....I need to know he's well and safe. Our need for him as husband and father is great. Please, I want him home. Wherever he is," she said, "I wonder if he's cold…because his overcoat was in the car. I wonder about his wellbeing." Then it was clear she began to speak to those not in the room. Sid had once told her, "To be outside in

Impromptu picture of Sid Reso. *Find A Grave, www.findagrave.com.*

touch with nature is a great healing." She illustrated this point by a line her husband once wrote for an Exxon report: "No business objective will take precedence over having respect for the environment."

If those in the press had wondered about the veracity of the information they were receiving from their "anonymous sources," Patricia Reso alleviated any doubt. She was speaking to the extremist environmental group she believed had her husband. Asked by one reporter how she was doing under the circumstances, she replied, "Some days, one is stronger than the other, and we all lend support." Each morning, she and her children "share the dreams they have had overnight about their missing loved one." In Patricia's dreams, Sid "talks to his family and tells them he is fine and 'he'll see them soon.' " In one of her children's dreams, she said they asked him, "Are you being beat up or anything?' and Sidney responded, 'Well a little, but you know it's not so bad' and not to worry." It was heartbreaking to listen to her and the torment she and her children were going through. Patricia concluded her message: "Please consider how much she [Sid's mother] has had to endure through this awful time....I appeal to anyone who may know of his whereabouts; please send him home...please allow him to spend Mother's Day with us all."

For the first time, the reporting was about Sidney Reso. People were learning about a husband who had been snatched from his driveway. No longer was it a story of a rich Exxon mogul's disappearance. This was a human story—a story of a good man who had disappeared and likely had been kidnapped. It was a story of a wife and her children who were distraught over their loss. This was a personal story of hope and prayer for a loved one's safe return.

The following day's newspaper coverage began a different perspective in their storytelling. "The portrait that emerges from interviews," said a *New York Times* article, "is that Sidney Reso was an executive who was not flashy, flamboyant, or idiosyncratic. He's direct, but he's not abrasive, not a desk-pounder, or anything like that." An unnamed executive was quoted as saying, "You wouldn't mistake [Reso] for a drugstore clerk, but he's not Lee Iacocca, either." Yes, Sidney Reso was a man of prominence, but he was also a man who drove a Volkswagen rather than being driven every day by a chauffeur. He was a man who gave to the poor, went to church every week and was a devoted husband and father. This part of the story was long overdue.

CASE GOES COLD

The assessments of the male caller came in from the voice experts assigned to analyze the recordings. All except one believed the recorded voice was not that of Sidney Reso. The lone dissenter was Dr. Murray Miron, perhaps the most respected of the analysts, an expert from Syracuse University in New York. Miron's experience in voice analysis was vast—far greater than the others. He worked with the FBI, the U.S. Marshals and the Royal Canadian Mounted Police on several criminal cases, most notably the Son of Sam case from New York City. Dr. Miron said the voice on the recording indicated the person was under "grave stress, duress and tension." This indicated to Miron that the voice was the missing executive's. Miron's opinion, unfortunately, wasn't given much weight, since Mrs. Reso and her children listened to the recordings several times and said it was not the voice of Sid.

Communication with the kidnappers was basically nonexistent. The FBI decided to relocate the command post out of the family's home. The case was obviously taking longer to conclude than anticipated. The investigation was growing more complicated and complex. A large space where audio and visual equipment could be housed was needed. Rich Riley identified space in his narcotics office on Hanover Avenue in Morristown, directly across from the police academy. It was a large brick building where the second-floor office space could be used to house the wiretap equipment, telephone lines and office space for the administrative staff.

A storage closet was identified in the room to secure the $18.5 million investigators were holding onto. The walls and doors protecting the money were reinforced, and technicians installed security cameras around the command post, with one looking directly at the "money door." Steve Foley was still responsible for protecting the money, which now had become an elongated assignment.

Telephone technicians brought several phone lines into the command post, and wiretap experts set up the eavesdropping equipment. Manning the command post was a task in and of itself. The center was the hub of the operation and needed to be staffed around the clock.

Operation SIDNAP had gone on longer than anyone could have imagined—normally, kidnappings don't play out this long. A case like this pushed the limits of those involved; fortunately, they had John Walker running the operation. "Walker was probably one of the brightest guys I ever worked with," said Ed Petersen. "He always pushed us to work with all agencies," which contributed to the excellent working relationship the team had going for it. Those working for John Walker enjoyed having him as a boss. "He always treated everyone equally," said Petersen. Walker was also efficient and according to John Turkington, Walker "never wanted to see an agent typing." He believed agents should be in the field doing what they do best, not laboring over a report. The team Walker put together for Operation SIDNAP was a talent pool that was unmatched in recent FBI investigative history.

The investigation over at Exxon headquarters, spearheaded by Turkington, was still ongoing. "We were interviewing folks about corporate security," said Turkington. "We were thinking this was a forcible kidnapping," since Reso's car was left running with the door open. "But we didn't want to discount anything, so we inquired about Reso personal life. Did his behavior change recently? Or did he have a girlfriend? And, possibly, were there any reasons in his personal life which would make him want to disappear?" These were tough questions, but they needed to be asked. These interviews revealed Sidney Reso had a normal life and wasn't the kind of person who would have a girlfriend. In fact, everyone who knew the man said he would never leave his family behind.

In addition to exploring his personal life, officials inquired if any threats against Reso—or any other executive for that matter—had been received. Turkington said they were also "reviewing HR files of employees who had recently left, and employees who were recently fired." They began looking at employee records from 1990, 1991 and 1992. It would be an exhausting

Mr. Reso will be held in total isolation with no food or water.
If you do not fully comply he will most certainly die. We have
observed and developed information on many of your personnel.
If we do not hear from you we will sieze another of your employees.

Prior to your delivery of the money we will demonstrate that
Mr. Reso is still alive. He will be released after the delivery
has been safely accomplished.

Any involvement by the police, FBI or media will be extremely
counterproductive. We will not negotiate these demands.

Fernando Pereira Brigade
Warriors of the Rainbow

Portion of the first ransom letter. *www.mylifeofcrime.wordpress.com.*

task, but they needed to look at everyone on that list. They would begin with those who were discharged and then move to those who resigned, retired or left for unknown reasons.

The team also set out to interview security professionals, including guards at all of Exxon's New Jersey sites. Agents were looking for any threats, no matter how trivial, the security department may have received in the hopes that one of these would connect to Reso's vanishing.

THURSDAY, MAY 14

Somewhere between all the noise within the command post, someone heard a phone ringing. It was an agent from the Texas office. They were in receipt of a letter that came to the Exxon headquarters in Irving. The letter was addressed to Exxon chairman and CEO Lawrence G. Rawl. It was posted marked May 12, and after examining it, they believed it was a legitimate message from the kidnappers. The note, like the previous correspondences, was typewritten and spoke in the same tone, suggesting it was not a copycat person sending it. And, according to an official FBI report, "Failure to make the ransom exchange had prompted" the kidnappers "to remove Reso from the country." This confused Walker and his team. They did everything requested of them the night of May 3. "It may have taken the FBI too long to set up or that the Reso family just did not move fast enough," the author of the letter wrote. Interestingly, the kidnappers knew the FBI had been involved. Agents wondered what had gone wrong. Thinking back on the night the ransom had been requested, Petersen arrived at Villa's Restaurant

reasonably quick. Whatever it was that went wrong, the kidnappers were obviously frustrated; "Proof Reso was still alive had been provided by having Reso dictate two of the previously received telephonic contacts," they wrote. This seemed to indicate all the voice experts were wrong except for Dr. Miron. "Further proof of Reso's wellbeing was left taped to a phone booth at the Summit, New Jersey Train Station, and should still be there." Concluding the letter, the kidnappers requested an ad be placed in the *New York Times* classifieds to "reestablish contact via cellular phone."

Agents were dispatched to Summit train station to clear the phone booth mentioned in the letter. No recording was found, but, according to an FBI report, "a piece of duct tape was found attached to bottom of shelf in phone booth." The two audio tapes were again played to Mrs. Reso and her children. Whether due to emotions or the scratchiness of the recording, they still couldn't hear the characteristic intonation of their loved one. The next morning, the *New York Times* was brought into the command post and opened to the classified section. The ad they placed read: "160 Acres, submit tape of property not received, current photograph of property needed, ready to close."

Later in the afternoon, a security officer at the Rockaway Mall received a call from a woman saying, "Information regarding the missing Exxon executive could be found attached to a sign post in their mall parking lot." The security officer hung up the phone and immediately called the Rockaway Police Department, who called the FBI. At the request of the FBI, Rockaway police officers recovered a demand note inside an envelope attached with duct tape to a sign. Inside the envelope was a three-page typewritten letter demanding Patricia Reso make an immediate statement to the media. They wanted her to say she was in possession of the written demand note. Furthermore, the letter blamed the FBI for failing to make the money exchange the night of May 3. The kidnappers wrote of returning Reso's credit card and the two telephone calls of recordings in "Reso's voice," saying these items were proof that they had the victim. They described a medicine container Sid had in his possession and expressed "displeasure at the failure of the Reso family to respond to the letter sent to Exxon, Irving Texas." The letter was signed "Warriors of the Rainbow."

Once again, the verbiage of the letter was curious to Tom Cottone, John Walker and Ed Petersen. Interesting was the use of the word "victim." This type of parlance is normally used by someone in law enforcement. Additionally, if the information contained in the demand letter was to be believed, Sidney Reso was no longer in the country. Walker, Petersen and

BIRDS

BABY CONGO AFRICAN GREY PAR-
ROT — $1,000 with cage. Call Michele
908-534-2991

"Purchase of rare international bird:
Proof of excellent condition your re-
sponsibility. Prepare to discuss trans-
fer. Last offer not received. Please re-
spond. Call 201-404-6713"

Another cryptic ad. *From the* New York Times *Classifieds.*

Cottone met with Patricia Reso in her living room to discuss receiving the new letter. Having the letter read was bothersome for the grieving woman. But somehow through this ordeal, she remained a pillar of strength. Patricia also had a strong connection to her children, and they were a good support system for one another. Arrangements were made with a local news channel to come to the Reso home so Patricia could make a taped statement that would be aired on the evening news program in accordance with the kidnappers' request.

FRIDAY, MAY 15

Sitting erect in a highbacked chair in her living room, Patricia Reso looked strong in her resolve. She wore a purple and white dress and a hint of pink lipstick and sported gold loop earrings. Her gray hair was neatly groomed, and thin-framed eyeglasses rested comfortably over her blue eyes. TV cameras were set up, and the bright lights made her skin look pale. With a strong voice she said:

> *I'm making a personal appeal to some people who I want to believe have my husband with them. I know in my heart he's alive. I pray that he is healthy. I want you to know that I have received your message. But, it is important to me that my kids and I have assurance that he is safe and unharmed. I am willing to do whatever is necessary to have him reunited with us. And I hope that he will be released very soon. I love Sidney and want him to come home to us.*

Seeing the harm being done to her and her family was emotional to watch. Patricia ended her statement asking the media to "stop any speculation" as to who the kidnappers might be. After the statement aired, the media questioned the FBI about the message Patricia Reso gave. They told the press they had "absolutely no information regarding any such message." As far as they knew, it was her just making a general statement. It was becoming increasingly evident to those paying close attention to what was transpiring in the written press that a covert communication scheme was taking place between the FBI and the kidnappers.

The assistant special agent in charge of the FBI in New Jersey, Jeremiah Doyle, met with the media to discuss the investigation. Doyle was John Walker's boss. With his dark hair, slim build and stern face, Doyle looked the part of the agent in charge. He said they had "no proof to date that Reso is the victim of a traditional kidnapping." As far as he knew, the case was being handled as a "missing persons investigation." Once again, for those paying attention, Doyle's statement was meant to extract information from the kidnappers. He wanted them to provide proof that they had Sidney Reso and he was, in fact, alive. This is evident by Doyle saying, "positive verification that someone is holding Mr. Reso" was needed. "In our opinion, [it] would be extremely unwise to accede to any possible demand" without knowing who is holding the executive.

Then in a "methodically toned voice," wrote Robert Rudolph of the *Star-Ledger*, Doyle provided a laundry list of ways for those who held Reso to prove it: "A telephone call, either live or taped, could be received with Reso mentioning the date or making a statement about a current event just reported on the news." Or they could submit a "photograph in which Reso is portrayed holding up at chest level a copy of a current newspaper." Then there could be a "handwritten note in which Reso refers to what he read in that day's newspaper." Doyle was clear that "verification has become important because of the lapse of time since the disappearance, and the fact that impostors could now be claiming to have information about the abduction or claim to be the kidnappers themselves."

Pat Reso. *From the* Star-Ledger, *photograph by Pattie Sapone.*

KIDNAPPINGS ARE RARE

TUESDAY, MAY 26

It was just after sunrise when John Turkington walked into the command post and bumped into Steve Foley, who was finishing up his shift. The two began discussing how little evidence made the case frustrating. Nearly a month had passed without anyone having a day off, and they were no closer to finding Sidney Reso. Everyone on the case felt the pressure. Mrs. Reso's May 15 television appearance appealing for those who had her husband to reach out had brought hope, but more than a week had gone by without a word from the abductors.

By 9:00 a.m., the investigative team had gathered to lay out the day's efforts and to review what field work was being done. The field agents had been out at several Exxon locations, while other agents were at the energy company's headquarters going through its human resource files. A little after nine—and several cups of coffee by many in the room—their phone rang. It was someone from the Morristown Memorial Hospital. They had just received a call "advising that a letter regarding Reso of Exxon" was in their mailbox. Walker immediately dispatched several agents to the nearby hospital, but no letter was found in any of their mailboxes.

Meanwhile, later that day, across the country in Los Altos, California, two men were waiting in a parking lot at the Adobe Systems Company. They were there for the company's cofounder, Charles Geschke, a wealthy

fifty-two-year-old executive who, like Sidney Reso, lived a modest life in the affluent area of Los Altos. The Geschke residence was a wood-and-red-brick structure hidden by the many redwood trees that lined his property. His wife, Nancy, whom "Chuck" called "Nan," was an active volunteer member of the American Red Cross. Like the Resos, they were people of means, but you wouldn't have known it.

It was nearly 9:00 a.m. on the West Coast when Geschke pulled his Mercedes 500SL into his assigned space at Adobe. The CEO got out of his car and popped his trunk to get his briefcase. As he closed his trunk, a car pulled up alongside him, and a man stepped out of the car with a map in his hand. The Adobe Systems building was in a commercial section, and people often find it hard to find the specific business they are looking for, so Geschke assumed the man was lost. "Can I help you?" he asked. The man pulled his map away to reveal a handgun, which he had pointed at Geschke's chest. "You're coming with me," the man said as he grabbed the CEO. He pushed him into the open door of his car and shoved him in the backseat. As the driver of the car quickly exited the parking lot, his accomplice placed duct tape over Geschke's eyes. "If you attempt to do anything," his captors told him, "we'll kill you." They made sure to tell him they knew where his family lived and "we'll kill them too." Then they told Geschke that an explosive device had been placed at his house. It was clear they wanted him to cooperate and were serious about it.

They brought their captive to a safehouse about thirty minutes away from where he was abducted, securing him to a chair in a room. There, they proceeded to interrogate the businessman about his personal belongings and finances. They wanted to know how much money he could get his hands on without delay.

In an eerie similarity to Sidney Reso's kidnapping, a series of events occurred. Nancy Geschke called her husband's work inquiring why he hadn't called her. When she was advised he never arrived she became "afraid he had had a heart attack." Employees at Adobe searched the area and noticed Geschke's car in his parking space. At 12:30 p.m., her home phone rang, and she rushed to it, thinking it was Chuck. It was not. It was a strange male voice on the other end telling her they had her husband and had taken him out of state. "If she didn't comply," the voice told her, "they would kill him." The kidnapper demanded $650,000 immediately and warned her to "keep silent, because she was being watched and followed." Nervous and afraid for her husband's safety, Nancy Geschke did not call the police. She then thought about her husband's partner, John Warnock, and worried he might be next.

Map of surrounding area of Morristown. *FBI SIDNAP media file, from an unknown newspaper.*

She called Warnock and told him of the call she received, setting up a meeting with him for 3:30 p.m. Then, she made several phone calls to "liquidate stocks into $100 bills." John Warnock, after being told of the circumstances, struggled with not calling the authorities. After an argument with his wife and clearing it with Nancy Geschke, the FBI was notified.

While FBI agents were busy interviewing Nancy Geschke at their office, agents were installing phone lines and wiretapping the Geschke phone for recording purposes. It wasn't until around 2:00 a.m. that the FBI concluded their interview with Nancy and sent her home. When she arrived home, she was bothered by the intrusiveness of the agents.

When FBI agents in New Jersey learned of the kidnapping, they thought there may be a connection. Kidnappings are rare in the United States, and they now had two happening within a month of one another. As agents were reaching out to their California counterparts, they received a call that a postal worker in Whippany, New Jersey, found a letter addressed to "Lawrence Rawl, Chairperson, Exxon Corp." Tom Cottone went to the post office and secured the letter. It read, "Reso [is] alive but located outside of the USA.... Reso will be executed immediately if full payment is not made on schedule." Then the letter shed some light onto how Reso was abducted: "Reso was kidnapped as he was retrieving his newspaper from the end of his driveway." The narrative was concluded with the signature of Warriors of the Rainbow.

Agents wondered if the timing of the phone call and the letter were somehow connected to the Geschke kidnapping. Eleven days had passed since they last heard from the kidnappers; now two communiques occurred the same day another business executive was kidnapped. When investigators learned of Mrs. Geschke requesting the ransom money in $100 denominations, they couldn't help but think the two abductions were connected. The coincidence just couldn't be ignored. When a conference call was made between East Coast and West Coast agents, they learned the

money request by Geschke's kidnappers was far below that of Reso's. And as they inquired further, they learned that the money being collected in $100 denominations was Mrs. Geschke's idea, not the kidnappers. There were also details with the phone call received in Geschke's case that didn't match those with Reso. One example is that Geschke's abductors had a Middle Eastern accent. The contrast between the two kidnappings became clear. The two kidnappings were not connected.

CRIMINAL PROFILE

The purpose of the Behavioral Science Unit (BSU) is to study and evaluate human behavior and patterns to aid investigators in their investigations. The BSU of the FBI is well known today due to the popularity of the TV series *Criminal Minds*. However, in 1992, the BSU was known only to the educated few.

Behavioral science, as described by Special Agent Greg Vecchi, is "nothing more than an umbrella term that encompasses interactions between individuals; group dynamics within social systems—it's all about understanding the meaning behind behavior." Simply put, it is the understanding of human interaction, behavior and common traits that are present in all individuals. Different portions of the United States have specific telltale signs that tell a trained BSU agent where the suspect is likely from. BSU agents evaluate these characteristics and compare them to their understanding and experience with people in general. Agents in the BSU are highly educated, with many having doctoral degrees.

The utilization of the BSU depends on the severity of the crime or its complexity. When it is used, agents of the BSU examine all evidence in the case to develop a profile, which will aid investigators in finding their suspect or suspects. The evaluation process includes listening to voice recordings and reviewing physical and microscopic evidence discovered. It didn't take long for the BSU to be called for assistance with the Reso investigation.

Where Is Sidney Reso?

In Case of Missing Executive, No Demands, No Clues, No Idea

Newspaper headline. *FBI SIDNAP media file, from an unknown newspaper.*

THURSDAY, JUNE 11

Seven weeks had passed since Sidney Reso went missing, and in that time, several letters were received from his abductors. Some of these were immediately acquired; others were discovered later. Poor communication and letter placement by the kidnappers were the cause of the drop in communications, but the kidnappers did not realize this. By now, the FBI was in possession of several letters, including the original April 30 ransom note, five letters from May and two from June. The latest letter came after the kidnappers called and gave instructions where it would be found. Each correspondence carried a threatening tone. According to the FBI, the kidnappers demanded an "ad be placed in the *NY Times* by Saturday. If instructions [were] not followed, Reso would die by Friday."

Each letter brought the agents of the BSU closer to developing their profile. They determined the kidnappers were likely not a radical environmental group but someone or someones who were thirsty for money. The assessment indicated those involved were from the United States and likely the state of New Jersey. The phraseology of the letters, the author's familiarity with police procedures and the rigid demands were indicative of a police officer. It seems Cottone's and Petersen's interpretation of one of the letters was accurate. According to the assessment, those involved were in their late thirties or early forties, probably Caucasian and driven by greed, not environmental vindication. "The notes," said Ed Petersen, "had a schizophrenic character to them, alternating between a very threatening tone and a more conciliatory one." Because of this, the BSU determined one of the abductors was a woman.

A forensic analysis of the first envelope revealed a blond human hair and a dog hair. The second recovered envelope had another blond human hair and dog hair. The dog hair was likely from a golden retriever. Interestingly, the woman they had a sketch drawn of had blond hair. Now, they had something to go on. Agents were sent to check pet shops, pet groomers and

animal shelters throughout the area in the hopes of finding a blond-haired female who fit the description in the sketch. It was a long shot, but since the BSU suggested the perpetrators were likely local, this lead needed to be explored.

THURSDAY, JUNE 18

With sporadic communication from the kidnappers, Tom Cottone was growing frustrated as the case agent. The case was dragging on, and the logistics of managing reports and putting them into the case files was distracting him from actively participating as an investigator. So Cottone went to John Walker and asked to be relieved of his "case agent" status and to just continue as part of the team. John Walker presumably was disappointed by this request but reassigned John Turkington as the case agent. Less than twenty-four hours later, a call came from the FBI's Newark headquarters replacing Turkington as case agent with Gail Chapman. The reason for this was not revealed. Presumably, it was a power struggle between Walker and his supervisor. Turkington had more experience and tenure than Chapman, but both were capable agents.

On Sunday, June 14, a male caller left a phone message on the answering machine of James Morakis. The voice on the machine said that it might be necessary to kill Reso to establish the kidnappers' credibility. Then the caller threatened to "abduct another Exxon employee until Exxon acquiesces to demands." The next night, another call came; Morakis's wife answered the phone. "Morakis, Morakis," she heard. It was obvious the caller was disguising their voice. The rest of the call was unintelligible. It was apparent that the kidnappers were growing desperate.

On June 15, an ad was placed in the Florida real estate section of the *New York Times* classifieds by the FBI in hopes of reestablishing meaningful correspondence with the kidnappers. "Central Florida Cattle Ranch. 160 Acres. Summit tape not received. Current photo of property needed. Condition of property your responsibility. Ready to close." The following night, while sitting in the command post at a quarter to midnight, Steve Foley picked up the hotline. The caller advised him to "go to Sheriffs Labor Assistance Program mailbox, 300 Route 24, Mendham Road. Note there," and hung up. Foley told Walker of the call, and Chief Rich Riley was called because he lived close to that location.

Left to right: Assistant U.S. attorney Victor Ashrafi, U.S. attorney Michael Chertoff and Morris County prosecutor Michael Murphy. *From the* Star-Ledger, *photograph by John O' Boyle.*

Speaking of this night, Riley recollected, "I get a call in the middle of the night and they say we need you to go retrieve a note the kidnappers left." Riley wiped the sleep from his eyes and asked where the location was. When told where it was, he said to himself, "I'm not going there alone," so he called Jack Dempsey, waking him up from his sleep. "Get your ass up!" said Riley. The assistant chief didn't say a word. "I'm picking you up," Riley told him and hung up the phone.

Jack Dempsey was running the office in Riley's absence and had not been involved in the investigation thus far. After being picked up by his chief, Dempsey was filled in on what they were doing and told he was "back-up" should this be a trap.

The night was dark, and the thick trees blocked what moonlight was present. Driving down Mendham Road, they approached the location of the mailbox that sat across from Lewis Morris Park. Riley was familiar with the mailbox and had always thought its location was perplexing, because it sat on the edge of an empty wooded lot. When they neared the box, Riley drove slowly and looked for indicators of the mailbox having been rigged with explosives. As he was doing this, Dempsey scanned the area looking for signs of an ambush.

Pulling the car along the wooded section about thirty feet away from the mailbox, the two lawmen got out and slowly approached. "It was a big metal

mailbox," said Riley. "I'm thinking if I pull this son of a bitch open is it going to explode." Dempsey was thinking the same thing. Standing in the dark, along the isolated road next to the mailbox, the close friends got into a bit of a disagreement. "Jack, open the mailbox," Rich told him, half joking but half serious. After all, Riley was the chief. "Fuck you," Dempsey told Riley, "I'm not going to open it." He was also half joking but half serious. The two laughed and were making light of a serious situation, but an explosive device for retaliation was a very real possibility. Needless to say, they needed to open the mailbox. It took a few minutes of them just standing there to come up with a plan. They picked up a stick and used it to open the mailbox. It took several attempts, but they finally got the lid open without it going "bang." Inside was an envelope. They opened the envelope and read the letter. It simply said to get ready; the kidnappers would be requesting the money exchange soon.

"CALCULATING AND COLD-BLOODED CRIMINALITY"

On the morning of April 29, while having breakfast with his wife, the fifty-seven-year-old Exxon executive could not have imagined his hopes and dreams for the future were just about over. He would no longer enjoy quiet nights at home or family get-togethers. Nor would he ever experience a relaxing vacation, let alone see the retirement he and his wife began to plan for. When Sid Reso embraced his wife that morning before getting into his car, their life together ended. Patricia didn't know it, but when she turned, taking her eyes off of Sid, that would be the last time she would see him. For waiting at the foot of the driveway were two cold, money-driven individuals hellbent on striking it rich. What these two people had planned for their victim was beyond the pale. As Sid drove along his driveway towards the street, all that remained for him was a short existence inside a wooden casket. The warm touch of his wife's hands would be replaced by the cold and callous hands of the two that were waiting.

With Reso firmly secured within his tomb, the drive to South Lincoln Avenue in Washington, New Jersey, was a bumpy one. There are three main routes to take from Jonathan Smith Road. One route winds through several country roads heading toward two major highways, Interstate 287 and Interstate 78. Another one runs through other well-traversed roads to Interstate 80. The last route twists and turns through primarily thick-wooded roads and two smaller state highways. Each option has its advantages, depending upon traffic conditions. The first two are strictly patrolled by police and offer an increased likelihood of encountering a cop.

With a man inside a wooden box in the back of their van, the couple in the van selected the latter. The rolling of the tires on the macadam reverberated through the small confines of that wooden box. Sid tried to kick and push the box open despite the pain he was enduring. The voices he heard were muffled and partially muted by the rattling of metal on metal from the thick padlock holding the box shut. His efforts were futile; the design of the box didn't allow for much movement. The man sitting in the passenger seat had designed it to limit his victim's movement.

An hour had passed since they stuffed their victim into their box. They had been planning this moment for months. They believed what they were doing would bring financial security to them. But despite their preparation and contingency planning, their abduction didn't go as planned. The male abductor—the dominant of the two—had threatened his victim at gunpoint but never anticipated Reso resisting. The culprit should have been able to maintain control of Sidney Reso. He was big and burly and had faced confrontation many times before. Moreover, the man was familiar with a handgun, having carried one since he was in his early twenties. And while the man failed to execute his part effectively, his female companion did the same. She was supposed to leave a ransom note with Reso's car. This note would instruct Reso's family not to contact authorities. However, when the gunshot rang out, she panicked and drove away once their prey was in the box.

More than an hour later, she pulled the van up to the entrance to the six-foot chain-link fence at 307 South Lincoln Avenue in Washington Township. They were at Secure Storage, a self-storage facility. The male stepped out of the passenger seat and entered the access code to open the gate. The gate's pulley wheels screeched as he walked back to the van. The female drove slowly towards the storage room they had rented in February for $125 per month, paying in advance through June. Secure Storage offered several sizes of storage rooms, ranging from five by five feet to twenty by thirty feet, constructed of prefabricated steel with concrete floors. The units were not temperature-controlled but had small vents for ventilation. The couple selected a twenty-by-twenty-foot shed for their needs.

The male jumped out of the passenger door once again to open the garage door of their storage shed. He remained outside and guided his female counterpart as she backed the van inside. Once inside, they closed the door. It was a strenuous task getting the plywood box with its metal braces and thick padlocks out of the van. Reso's weight of 180 pounds added to the already heavy box. With a mouth taped shut, bound feet and

"Purchase of rare international bird: Proof of excellent condition your responsibility. Prepare to discuss transfer. Last offer not received. Please respond. Call 201-404-

Communique. *FBI SIDNAP media file, from an unknown newspaper.*

handcuffed wrists, one can only imagine the pain and anguish Reso felt as the box dropped hard onto the concrete.

The unseasonably warm temperatures and poor ventilation made the storage room suffocating. With the box out of the van, the couple struggled to push it across the room. Once they had it against the wall opposite the garage opening, the man reached into his pocket and pulled out a key. The single bulb dangling from the ceiling provided little light, making it hard to find the keyhole on the padlock. Once it was unlocked, the man opened the box, and in the pale light, they saw the face of Sid Reso. He moaned in agony as they lifted him out. His face was bleeding and his eyes were bloated from the beating he received. His forearm and wrist were swollen, and blood leaked from his bullet wound. The bullet had caused considerable damage to Reso's forearm.

The male culprit's thick, pale fingers ripped the tape from Reso's mouth. With the ability to speak, Sid asked the man to cut off his watch because the swelling made it hurt. After the watch was removed, the woman walked over and poured peroxide onto his wounds. She didn't look like she could harm anyone. Her soft blond hair and attractive blue eyes concealed the cruelty within her heart. After cleaning her victim's wounds, she wrapped the forearm with gauze. The gray duct tape around his legs was unwrapped, providing temporary relief for the executive. Sid told his captors he would do whatever they wanted if they didn't put him back into the box. However, his plea went unanswered, and they wrapped him back up with duct tape, handcuffed him and put him back inside. As Sid Reso moaned and writhed back and forth, the lid was closed and padlocked shut.

The room was already heating up by the time they pulled the van out of the shed. The sound of the churning metal wheels of the garage door echoed throughout the storage room. The temperature inside the storage room was hot, but inside that plywood box it was intolerably hot. By midday, the temperature outside rose to eighty degrees, pushing the temperature inside the storage room and Reso's box to over one hundred

degrees. The air was still, stale and stagnant. The holes drilled into the top and sides of the plywood for air provided little relief and didn't allow for proper air circulation.

As Sid Reso lay inside the oxygen-deficient casket, he began to breath in his own expelled air, which was laced with carbon dioxide. Breathing in the carbon dioxide caused Reso's breathing rate to increase and his skin to become clammy. The intense heat inside the casket had a direct impact on his wellbeing. What followed next are the physiological effects known to occur with increased carbon dioxide inhalation. He became fatigued and weak. By the time the couple came back—twelve hours later—the physical effects of oxygen deprivation and increased carbon dioxide had weakened Sid Reso to the point where he was defenseless. If he wanted to resist, he physically couldn't. Compounding matters was that his captors had no plans to render aid to him. A few times they gave him a sip of water or orange juice. They gave him no food because they didn't want him to "go to the bathroom." The opening of the shed's door provided a brief exchange of old air for new, but that didn't matter. Neither did the cooling evening temperatures. Sid Reso's carbon dioxide intake put him in need of immediate medical assistance—assistance that would never come.

On Thursday, April 30, at 7:15 a.m., the garage door opened. The two predators entered and opened the casket. Reso was clammy, groggy and disoriented. Those thick, pale fingers switched on a recording device, and the man asked Sid Reso to read two statements. These recordings were the ones captured by the FBI but unidentified by Patricia Reso and her children.

Meanwhile, the summer-like temperatures brought people out in droves at the Morristown Green. Neighborhood sidewalks were traversed by people seeking the warmer weather. As people enjoyed the sunshine, Sidney Reso was baking inside his wooden tomb. The exact rate at which the carbon dioxide affected Sidney Reso cannot fully be known, but common physiological effects for someone exposed to carbon dioxide for this period would likely include a breathing rate double that of normal along with elevated blood pressure. By Friday, May 1, Sid Reso's health was deteriorating rapidly. Because they never took him out of the box, he was forced to relieve himself in his pants. If it was hard to breath in the beginning, it was even more difficult with the smell of urine and feces filling the air of his tomb. When they came to visit their victim this day, they discovered that he was barely conscious and probably delusional from his carbon dioxide intake. Needless to say, they did nothing to relieve their victim's conditions.

After having breakfast at home on Sunday, May 3, the couple took the short drive to the storage room to check on their victim. If someone was watching them, the only thing that would have stood out as unusual was their preppy clothing. The man was of average height and had a muscular build. He was good looking with wavy blond hair. The woman with him was slender with a warm and welcoming smile. She too had blond hair and an attractive face. It was 12:30 when they opened the door to the storage room. The midday sunlight illuminated the wooden box tucked in the back. No sound—not even a whisper—could be heard.

"I went to get water and Tylenol on one side" of the shed, said the woman. While she was doing so, her husband opened the lid. "I could hear a commotion," said the woman. She looked to see what it was, and the man was doing "chest compressions" on Reso. The key to their fortune was at the tip of this man's callous hands. As the man frantically tried to bring Reso back to life, the woman "walked right over." But she knew "he was dead" because he had "absolutely no color." The efforts to save Sidney Reso were in vain. They had offered no food to Reso and provided little water, and somehow the two were surprised that Sidney Reso was dead.

"We proceeded," says the woman, "to lay black plastic on the floor of the storage facility.…We took him out of the box" and removed "all his clothes." They then put his belongings into a garbage bag. With only his

Left to right: Prosecutor Michael Murphy, Patricia Reso and U.S. attorney Michael Chertoff. *From the* Star-Ledger, *photograph by Pim Van Hemmen.*

boxer shorts on, they wrapped Sid Reso up in plastic. The box was cut up and put in "several garbage bags." The van was then backed to the garage door and loaded with the debris. If someone had peered into the shed as the van drove out, they would have spotted what looked like a rolled-up carpet lying in the back. It was the body of Sidney Reso, wrapped in dark plastic. The couple would come back for him once they decided what to do with the body.

HILLSIDE, NEW JERSEY

In the shadows of the much larger city of Newark sits Hillside, New Jersey. In the 1940s, Hillside was a small community consisting mostly of laborers. Crime was scarce, and people were friendly. It was a quiet town whose residents worked at the seaports of Newark and Elizabeth. In the late 1940s, the city of Newark entered a period of decline, which brought increased crime into the city. As years passed, that criminality bled over the city's borders into adjacent communities, with Hillside being one of them.

The history of Hillside isn't filled with accomplishments or notable occurrences—rather, the history is of families working to provide for their loved ones. People here simply worked hard, went to church and contributed to their community, hoping that the next generation would be better off than the one before. Illustrative of this is the Woodruff House, at 886 Salem Avenue. The white colonial home and property tell the story of the community through the Woodruff family. Town officials have made the home a museum that displays the artifacts of the family. Their story is a study of life during colonial America and the struggles and hardships early Hillside residents had to endure. Many of these events are chronicled in diaries and letters kept by the family. Much has changed since that time, but the human struggles and family dynamics of living in Hillside have not.

The story of Arthur L. Seale and his wife, Daphne, is not that different from the Woodruffs. They, too, lived in Hillside and tried to provide for their family. Arthur and Daphne had two children: Arthur, born in 1946, and Karen, born in 1951. Daphne was a beautiful woman who worked as

a school secretary, while her husband was a police officer in Hillside. When Arthur L. Seale began his duties as a peace officer, the police department had only a handful of personnel. With the passing of time and increased crime entering the township, Hillside began growing its police force. The expanding department allowed for promotional opportunities for the young officer. Arthur proved to be a dedicated, dependable and competent officer. As a couple, the two—like the Woodruffs—participated in many social events in Hillside and became an integral part of the community.

What did change since the foundation of the town was a social split between residents. As houses were built, the town began to segregate into the "haves" and the "have nots." There are two distinct sections of Hillside: one comprised of the middle class, the other the upper class. Long before Hillside's incorporation, the former were known as hard-working, blue-collar men and women, many of whom were employed by the factories in town or in Newark and Elizabeth. The pharmaceutical corporation Bristol-Myers Squibb's factory in Hillside employed a great number of the town's residents. The homes that began to spring up in the middle-class section were cookie-cutter structures with small lots to house the residents of the nearby factories and seaports. Many of these homes are two-family dwellings that were either rented or housed more than one family generation. Contrasting this was the upper-class part of town, known as Westminster. The Westminster homes were bigger, sat on larger lots and were constructed with aesthetically appealing architecture. These residents are business executives, senior management and other high-income workers, the most famous being New York Yankee Phil Rizzuto.

Needless to say, Arthur L. Seale and his wife, Daphne, didn't live in Westminster. The Seales lived on Woodruff Avenue in a modest house nestled firmly within the blue-collar part of town. As years moved forward, their son Arthur, or "Artie" as he was affectionately called, was enamored by his father. Fathers often appear larger than life, and adding to this, Artie's dad wore a blue police uniform and a shiny badge. Boys of this generation watched movies with John Wayne as the lawman and television programs like *State Troopers* with Rod Cameron or *Highway Patrol* with Broderick Crawford. Many young boys fantasized about being a lawman and fighting crime. Artie's dad did just that—he was a real-life hero. A police officer's job is not an easy one; the job requires working odd shifts, weekends and holidays, and the stresses police encounter cannot be fully understood by those not carrying a badge. However, the stories his father told him began to attract him to policing. As Artie grew, he enjoyed some of the benefits police

MISSING PERSON

Morris County Prosecutor's Office	Morris Twp. Police Dept.	F.B.I.
Courthouse	49 Woodland Avenue	Garret Mt. Plaza
Morristown, NJ 07963-0900	Convent Station, NJ 07961	West Paterson, NJ 07424
(201) 285-6200	(201) 326-7457	(201) 622-5613

The Morris County Prosecutor's Office and the Morris Township Police Department, in cooperation with the Federal Bureau of Investigation, the New Jersey State Police, and the Morris County Sheriff's Office, commenced a missing persons investigation on April 29, 1992.

Reported missing was Sidney J. Reso, age 57, of Morris Township, N.J. Reso, president of Exxon International, was last seen by his wife leaving his residence at 7:30 A.M. on April 29, 1992. Reso did not arrive at his Florham Park office as scheduled.

DESCRIPTION

RACE	WHITE
SEX	MALE
AGE	57
D.O.B.	2/12/35
HEIGHT	5'-10"
WEIGHT	180 LBS.
HAIR	GREY WITH RED TINT
EYES	BLUE

Missing person flyer. *Provided by Agent John Turkington.*

officers provide exclusively to family members—benefits such as getting a ride home from school or minor traffic infractions being overlooked.

As an adolescent, Artie Seale was seen as a good kid who rarely got into trouble. His peers and teachers all agreed that he was likeable. While in school, Artie was an above-average student and was viewed as bright and eager to learn. His after-school activities consisted of playing football, baseball or other physical activities with his pool of friends. With each passing schoolyear, the young Seale grew stronger and developed a

muscular physique from his rigorous workouts. By the time he entered his teenage years, Artie was a good-looking kid with strong facial features. His blond hair and blue eyes caught the attention of more than a few young ladies in town.

One of these was a slender teenager known to everyone as Jackie. Jackie had a cute figure, wavy blond hair and eyes bluer than Artie's. As Artie came to find out, Jackie was just a nickname; her real name was Irene Jacqueline Szarko. She lived in the Westminster section of town. Irene Jacqueline and her brother, John, lived with their parents at 969 Revere Drive, only a few blocks from the blue-collar home of Artie. Jackie was "born into a family of modest wealth," recalls Ed Petersen. Her father, John Szarko, and her uncles Walter and Fred were successful businessmen in Hillside. The family money didn't originate from this business—the money came from Jackie's grandfather Michael Szarko, a real estate investor and businessman with landholdings throughout Hillside. Of the many landholdings he had, the storefront at 1317 Liberty Avenue was now the main source of revenue for John Szarko and his siblings, not considering the inheritance they received upon Michael's passing.

The Szarkos were second-generation residents of Hillside and were known by just about everyone in town. In a predominantly middle-class community, the Szarkos were considered rich. Vito Menza, a local real estate agent and friend of both the Szarkos and the Seales, said "Jackie Szarko didn't want for anything." While Jackie's father catered to the family business, her mother, after whom she was named, was a registered nurse. They were a "lovely family," recalled Menza, and their daughter had an effervescent personality. She was athletically inclined and enjoyed physical activity to keep herself looking fit and trim. Her athleticism, figure and warm personality are presumably what attracted Artie Seale to her.

Soon Jackie and Artie were being described as lovestruck "high school sweethearts." In the hopes that Artie would go on to college, Arthur L. and Daphne sent him to the strictly structured Admiral Farragut Academy in the shore community of Pine Beach, New Jersey. Admiral Farragut Academy is a private military prep school that prepares young adults for admittance into the Reserve Officer Training Corps (ROTC). While in attendance, Art (as he was now called) did well academically, receiving a B average. Captain John Matthies, a graduate of the school who rose to be its superintendent, said Seale was "a popular, well-rounded student who played varsity football and track." Matthies said Seale was "smart, athletic and handsome." This made him very popular amongst the student body.

Although the two were far apart, Art and Jackie's love for one another grew, and talk of marriage began. This upset Jackie's parents, because she was attending Boston University, not to mention she was only nineteen years old. The Szarkos thought that marriage could wait until after college. Nevertheless, Jackie was enamored with Art, and he convinced her to drop out of college to elope. Art had done some research and discovered the town of Elkton, Maryland, was a popular destination for people who wanted quick weddings. Elkton is just over the Delaware border and only a four-hour drive from Hillside. Known nationwide as the place to elope, Elkton was the setting for the weddings of actresses Debbie Reynolds and Joan Fontaine. Art and Jackie exchanged vows in a small rock-facade chapel on a cool Saturday morning, September 30, 1967.

Despite not approving of the marriage, John and Irene Szarko allowed their daughter and her new husband to move in with them. The next few years became a strained period under the Szarko roof. Art's "fly off the handle" temper didn't bode well with his in-laws. Jackie's parents had a long marriage with little friction or tempers within the household. Compounding matters, Art had been attending college at Rutgers University but grew tired and dropped out. Their son-in-law's failure at academics and inability to get a job angered Jackie's parents. Art and his mother-in-law argued often. To the ambitious Szarko family, Art appeared to be an angry and unambitious young man.

BEHIND THE BADGE

February 1968 brought a protest in Orangeburg, South Carolina, that turned into a mass shooting of protestors by police. When the smoke cleared, more than twenty people had been shot, with three black men killed. To this day, the reason for the shooting is in question; some say protesters fired first on police. Others say it was police who opened fire on the crowd without provocation. The incident, known as the Orangeburg Massacre, turned out to be the initial spark in racial tensions between police and the black community. Two months later, in April, Dr. Martin Luther King Jr. was assassinated, and King's death brought about riots in over 120 cities across the United States, including Chicago and Washington, D.C. It was a troubling time in American history, and calls of racial injustice and police brutality were rampant.

Police officers around the country found it hard to do their jobs, especially in urban communities. Each night, news programs broadcast the friction between police and the minority community. It was during this time of friction between law enforcement and the black community that the thirty-eighth class of the Essex County, New Jersey police academy embarked on their training.

The police cadets were a diverse group from Essex and Morris Counties. The all-male class consisted of thirty-two people from Essex County, Caldwell, North Caldwell, Wharton, Orange, West Orange, East Orange, Belleville, Roseland, Millburn and Hillside. Their thirteen-week training program began in the first week of April and was a difficult journey of

ESSEX COUNTY POLICE ACADEMY

BASIC POLICE

TRAINING PROGRAM

GRADUATION EXERCISES

THIRTY-EIGHTH SESSION

JUNE 21, 1968

West Orange Armory
Pleasant Valley Way
West Orange, N.J.

Seale's academy booklet. *Provided by West Orange police officer Richard Costello (retired).*

academic courses in spelling, report writing, police conduct, constitutional authority and community policing. If the academics seemed difficult for the group, the physical training must have felt intense. They were put through daily physical exercises consisting of sit-ups, pushups, running, self-defense and firearms training.

Participating in this class was Arthur Seale, who hoped to follow in his dad's footsteps. The nightly news continued to cry for better-trained police officers. Considering that few in law enforcement, including the instructors, had a college education, the academy staff were under a great deal of pressure to provide adequate training. If those in the academy didn't realize the dangers of policing before beginning, the instructor staff reminded them every day. One of the themes of the academy training was "In today's distressing times, there seems to be public apathy towards law enforcement."

In the tenth week of training, Senator Robert F. Kennedy, who was running for the Democratic presidential nomination and was a strong supporter of equal rights, was shot and killed. Tensions boiled over once again, and the future officers began to realize they were entering a field of extreme controversy and danger. Making events worse were the Black Panthers. Established two years before King's death, the Panthers agitated matters, which created a wider racial divide.

The Blank Panthers' mission statement was to monitor police behavior with armed citizen patrols. The assassinations of Martin Luther King and Robert Kennedy fueled the Black Panthers' cause. Because of this movement, many activists founded black-run stores and other organizations. Instead of bringing different racial groups together, this isolated non-black people. White officers were accused of being racist, and black officers were accused of being part of the establishment.

In the city of Newark, racial tensions between police and the black community were no different than they were in Chicago or Washington, D.C. The problems of the large city began to bleed over into Hillside. Because of this, officials in Hillside were eagerly waiting for their new police officer to

complete his training. Arthur Seale's graduation was special because he was the son of one of their own.

On Friday, June 21, 1968, an impressive quasi-military ceremony at the New Jersey National Guard Armory on Pleasant Valley Way in West Orange was held for the graduating class. Arthur and his wife, Daphne, sat in the audience with pride and glee as their son walked up and accepted his police badge.

The first year for the twenty-two-year-old officer was spent learning what cops call "the ins and outs" of policing. This is the formative period when police officers learn the area they are patrolling and how they should deliver the services of a law enforcement officer. Art Seale had an advantage, since he knew the Hillside streets. As a child, there wasn't a part of the three-square-mile town he didn't roam. During this first year, Seale also learned of the paperwork that is required to be a police officer. He also realized that the streets he used to play in were becoming increasingly filled with criminal activity. The unfolding civil unrest brought each officer in town under what was called "heightened alert."

Not long after Seale became an officer, a string of domestic terrorist bombings started taking place in New York City. These domestic bombings were clearly an extension of the civil disturbances of the 1960s. The year 1969 brought about what became a continuing string of radical groups wreaking havoc in the city streets of mainland America. Additionally, the Black Panthers continued to grow their membership, and their presence threatened the safety of police officers patrolling the beat. The civil unrest continued, and the bombings spread throughout the United States—over 2,500 bomb attacks occurred between 1971 through 1972. It was a dangerous time in modern history for policing. Many of these bombings took place during the overnight hours, causing speculation that those effectuating the bombings weren't looking to cause mass causalities but rather to send a message. Others, however, said the overnight bombings were just a sign of what was to come.

At first, Art Seale seemed to adjust to the difficulties of policing and the rotating shifts. And although his father might not have admitted it, the job had changed since he had joined the force. With the bombings continuing, police departments increased their ranks. Hillside was no exception. With the increased hiring, Art was no longer one of the junior officers, and his father moved up through the ranks and became the deputy police chief.

Increased seniority, however, didn't bring about a more reserved and mature officer. Instead, Art went down a path of problematic behavior.

Michael Murphy during a press conference. *From the* Star-Ledger.

It soon became apparent that he wasn't stable like his father nor half as capable. His father was professional, whereas Art was quick to anger. His father made good decisions; Art simply did not. If not for being the deputy's son, decisive disciplinary action would have been taken. However, because of who he was, officials were more tolerant. A feeling of favoritism began to permeate within the department, resulting in many officers turning against Art. It can be presumed that Seale took liberties other officers would not even think of doing because he knew there wouldn't be any repercussions. Because of the blatant nepotism taking place, several officers complained to the township officials.

The year was now 1973—a year that brought a series of events to the national headlines. First, CBS sold the New York Yankees to a group of investors led by George Steinbrenner. Then there was the landmark Supreme Court decision of *Roe v. Wade*, which declared that a woman's right

for due process extends to her right to have an abortion. President Richard Nixon signed the Paris Peace Accord, putting an end to military action by the United States in Vietnam. In South Dakota, an incident ignited racial tensions of a different sort when a group of Native Americans occupied the Pine Ridge Reservation near Wounded Knee. The event initiated a seventy-one-day standoff in which at least one U.S. Marshal was shot and two Native Americans were killed. In May, Joanne Chesimard shot and killed a New Jersey state trooper on the New Jersey Turnpike. Chesimard was a member of the Black Liberation Army, an offshoot of the Black Panthers. This killing was a stark reminder to law enforcement officers in New Jersey of the dangers they faced.

However, for Arthur and Jackie Seale, 1973 was turning out to be a good year. Jackie had graduated from college with a degree in education and was working as a substitute teacher. Also, Jackie gave birth to a son they named Justin. Art and Jackie were very much in love and were overjoyed as parents. Around this time, they moved to Lebanon Township, living in a home adjacent to the Swackhamer Lutheran Church on Anthony Road. The Seales became friendly with their next-door neighbors George and Peggy Polt. In fact, Peggy and Jackie became close friends. Jackie expressed to Peggy that she would like to become friendly with more people in the neighborhood but found it difficult. In an attempt to help her out, Peggy tried to get her friend Howard Symonds to befriend the Seales. Peggy said she pushed Symonds toward the Seales "because they didn't have many friends." However, despite his friendship with Peggy, Symonds wanted no part of the Seales. He said he and his wife "didn't feel inclined." The Seales were "kind of quiet [and] kind of weird." When asked to explain what he meant, Symonds stated, "I don't know how to explain it." There was something about Art and Jackie that made Symonds uneasy. "I don't know how to put my finger on it," Symonds explained. With colleagues at work expressing objections to favoritism, Seale found it difficult to develop friendships there as well. Maybe because they had few friends, Art and Jackie grew closer together. Time would certainly bring a host of friends, they must have thought. For now, they had their relationship and a baby boy to take care of.

Once officials outside the police department became aware of the unfair treatment by senior officers, they cracked down on the police hierarchy. Sometime in June or July, Art Seale was brought up on charges of insubordination. An internal investigation into the matter ended with Seale being found guilty and suspended for thirty days without pay. This punishment was a financial setback, especially since they had a newborn

to clothe and feed. The following year, Seale's performance continued to break down. Early on in the year, Seale was brought up on charges of undue force. The department kept a tight lid on this incident, and the actual report has proved elusive. However, what can be gleaned from the few accounts that went public is that Seale had fired a warning shot to get a suspect to stop fleeing. Then he falsified the arrest report to cover up his actions, which brought a secondary charge of a reporting procedure violation. The disciplinary board delivered a five-day suspension without pay. The impact this had with Jackie, if any, isn't known, but the Szarkos weren't pleased.

The sphere of protection provided by the deputy police chief continued, and it worried town officials. Former mayor Jim Welsh told the *Wall Street Journal* there was "a general feeling that because he was a deputy chief's son, a lot of things Seale did were not reported to the governing body." An internal investigation was conducted that validated the complaints of officers about favoritism. To some degree, everyone understood a father wanting to protect his son. However, Seale's conduct was too worrisome for anyone, let alone a father, to ignore. The younger Art Seale did not have the level-headedness of his father nor the discipline or control.

For a time, at least, officials were cautiously hopeful that Seale would curtail his problematic behavior. The complaints slowed and then completely ended in the calendar year of 1975. Then, while making an arrest, witnesses said he "scared the living hell out of" them. Once again, details of this incident are elusive. The internal investigation that followed brought a charge of violating a direct order. A mix of sporadic information

NEW YORK POST, THURSDAY, MAY 7, 1992 5

DID ECO-TERRORISTS SEIZE EXXON EXEC IN N.J.?

By CARL J. PELLECK

Has Exxon executive Sidney Reso been kidnapped by a mysterious organization calling itself the Rainbow Warriors?

Authorities don't know yet — but they are looking into a ransom note received from a group claiming to be his abductors, a top law-enforcement source told The Post.

The note, signed by the Rainbow Warriors, ordered authorities to "have a lot of money ready . . . Instructions will follow," the source said.

Two other calls followed the disappearance a week ago yesterday — one on Friday, one on Sunday.

The source said he had no knowledge about any group called the Rainbow Warriors — but the name led to speculation that Reso may have been grabbed by environmental terrorists.

An environmental-watchdog ship named Rainbow Warrior was sabotaged and sunk in 1985 by French secret agents.

The source said authorities have not yet determined whether the calls and note are legitimate or the work of a prankster.

Reso, 57, disappeared mysteriously from the driveway of his Morris Township, N.J., home on April 29 as he set off for work. His car was found idling in the driveway with the driver's door open.

Late the next morning, a call from his alleged kidnappers was received at Exxon headquarters in Florham Park, the source said.

The call — a taped message — directed authorities to a New Jersey shopping mall, where a note was found, the source said.

Officials in the Morris County prosecutor's office and the Newark office of the FBI said they knew nothing about the alleged calls and ransom note.

"There's really nothing new," said Lois Ferguson, spokeswoman for the prosecutor's office.

FBI spokesman Bill Tonkin said: "I've been involved in this investigation from day one and have no knowledge of that."

Exxon spokesman Jim Morakis echoed Tonkin, saying, "I don't know anything about it."

Last Thursday's phone call to Exxon was a tape-recorded message that was largely inaudible, said the law-enforcement source.

When the person who answered the call made it clear that it was hard to hear, the message was replayed, the source said.

Another tape-recorded call was received by Exxon the following night, and one of a similar nature was made to Reso's home on Sun-

day, he said.

The Sunday call is the last known contact, the source said.

After the Greenpeace ship Rainbow Warrior was bombed by French terrorists in 1985, a new ship, Rainbow Warrior II, was built by the environmental group to replace it.

But Greenpeace spokeswoman Blake Palese said she is sure her group had nothing to do with Reso's disappearance.

"It's definitely not us," she told The Post. "We're strictly non-violent. It is something we would neither advocate nor support. We would condemn it."

Reso heads Exxon International, the chief foreign division of the Dallas-based Exxon Corp, the nation's biggest oil company.

SIDNEY RESO
Note from Rainbow Warrior

Information leaked to the press. *From the* Star-Ledger.

suggests that Seale used his .38-caliber service revolver inappropriately. Digging deeper into this claim, it is discovered that Seale, while making an arrest of a man, used excessive force. When the man's mother tried to intervene, Seale struck the woman in the face with the butt of his gun.

The bicentennial year of 1976 brought about a nationwide celebration. Every month was an anniversary for a significant event that helped break the bonds of British rule. This year, independence wasn't just going to be celebrated on July 4. The U.S. Mint issued bicentennial quarters, half dollars and dollar coins displaying "1776–1976" in honor of the country's most important year. Everywhere, people were hanging American flags. Many homes were refurbished with accents of the colonial era. The year was a celebratory one, to say the least. On the other hand, for Art and Jackie, it was a year of conflict at work and continued financial setbacks.

Early in the year, Art was charged with conduct contrary to good order and discipline and received a five-day suspension without pay. When he returned to work, his abrasive demeanor continued. Then one day while working a plainclothes detail, a call of an armed robbery rang out on his radio. As Seale was responding to the call, he observed a suspect running away from the scene and pursued him. The foot chase went through several backyards and city streets until Seale and the perpetrator were in the streets of Newark City. A Newark police officer in a patrol car spotted the two men running and drove after them. It was a hectic scene, and according to witnesses, the Newark cop saw "a white guy running out into the street with a gun" and assumed he was the bad guy. The injury left Seale with an eighteen-inch scar running from his lower calf to just below his right knee and put him out on disability for the remainder of the bicentennial year. While home recuperating, Jackie gave birth to their second child, a daughter named Courtney.

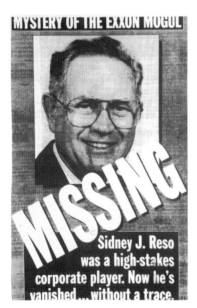

New York Daily News cover page. *From the* New York Daily News.

The injury was taking a long time to heal, and therapy was going slow, leaving Art out on disability for the majority of 1977. In the fall of that year, it was finally

determined the injury would prevent Seale from being able to perform the job of a police officer. Seale's injury brought about the opportunity for town officials to end their relationship with the problematic officer. A look at his track record while a Hillside officer shows that in five of the nine years of his employment—1972, 1973, 1974, 1976 and 1977—Art Seale had received disciplinary action. Officer Art Seale was granted a disability pension of two-thirds of his salary, equating to $10,000 a year. Interestingly, the day after Seale was granted his disability pension, he went skiing.

EXXON

Exxon Corporation has offices around the world, with headquarters in Irving, Texas, and during most of the 1980s, Lawrence Rawl—a longtime Exxon executive—was the CEO. One of Exxon's most productive and busiest offices was on a large parcel of land in Florham Park, New Jersey. It is here that the president of the company's international division, Sidney J. Reso, had his office. The campus in Florham Park was a city onto itself. A maze of paved roadways and concrete sidewalks were filled with over six hundred employees traversing the property. With an organization as large and diverse as Exxon, it is hard to imagine how each location, whether in New Jersey or abroad, ran so efficiently. Nonetheless, Exxon thrived, mainly because of its strict policies and oversight. Through the years, the company had developed a highly functioning chain of command, with each person and location reporting up the chain, ultimately leading to the desk of Lawrence Rawl in Texas. The Exxon structure was unique and allowed for uniformity of control without the rigidity that can curtail creativity.

As can be imagined, the security operation for Exxon and all its facilities around the world was immense. The company's security department is comprehensive, consisting of specialists in a variety of fields to address the various security threats that exist. Each location is unique and consequently will have specific measures tailored for it. But it is certain that each location has security cameras and fire and burglary detection technology along with enhanced lighting and physical perimeter protection measures. A major

supportive function of Exxon security is its investigative department, which deals with all matters of internal security.

For many entering operations within Exxon security, the starting point is the executive driver position. At Florham Park, like all other locations, executive drivers transport and protect officials assigned to or visiting the specific Exxon location. Despite all the rules and procedures set forth by Exxon, its recruitment process for drivers was simplistic in its approach. Officials at the Florham Park campus filled their driver positions by recruiting from local police departments. They believed the police network was a good way to find qualified drivers. Each year, a handful of officers become eligible for retirement and are looking for second careers. There was no shortage of police personnel with Morristown, Hanover, East Hanover, Madison, Chatham, Livingston, Millburn and Summit being close to the campus.

It wasn't long after Art Seale retired that an opening for an executive driver became vacant. The security manager at the Florham Park campus was Anthony Maravel. A former police officer, Maravel knew the skills required for Exxon's executive driver team were tailormade for cops. Officers spend their careers maneuvering their cars in and out of traffic, often at high speeds. Moreover, police officers are trained in threat identification and situational awareness, and most excel at crisis and emergency response—skills crucial for his driving team. Through the years, Maravel had developed relationships with the surrounding police agencies and took advantage of this professional network when recruiting members for his executive driving team.

Maravel called several police departments but found no prospects until he called Hillside Police. There, the secretary taking Maravel's call forwarded him to the deputy police chief. The elder Seale told Maravel about his son and how he had to retire early due to an on-the-job injury. Maravel was told the younger Seale would be a good fit for the position if afforded an opportunity. An impromptu interview between Anthony Maravel and Art Seale Jr. was set up off the Exxon campus. Presumably, Maravel wanted to get a feel for the recent retiree. The ex-cop and executive thought Art Seale a viable candidate, so he set up a formal interview for Seale with his superior. According to Exxon personnel, Art Seale "looked the role of an executive driver." They liked his physique, his manner of speech and the way he comported himself.

The pool of drivers on Maravel's security team consisted of approximately half a dozen people. Most of the executives from the Florham Park office refused regular drivers; rather, they would schedule drivers when they felt

FLORIDA REAL ESTATE (356-357)

Florida 356

CENTRAL FL CATTLE RANCH,
160 Acres, Summit tope of property not
received, current photograph of
property needed, ready to close.

U.S. GOV'T R.E. CLEARANCE SALE
The U.S. gov't has 75,000 properties
from failed banks that must be sold at
any price. An up-to-date list, full de-
scription and gov't rep to contact can
be purchased for Florida or any state
from Consumer Center 1-800-USA-0121

The FBI asks cryptically for proof of life. *From the* New York Times *Classifieds.*

they needed them. Normally, this meant the executives were traveling to other locations or out of state. Only a handful of executives used the driving team for daily pick-ups and drop-offs. This made scheduling a little complicated.

In the weeks and months that followed, Art Seale did well in his new role. The executive driver position seemed better suited for his temperament. No longer did he have to cope with a complaining motorist or a resisting criminal. He simply needed to be friendly to the executive, help him or her out when asked and drive safely. The position was easier for the high-strung Seale. Surprisingly, Art Seale didn't seem to mind opening doors and helping to take out trash and bring in the mail, which is often what he was asked to do.

With any new job, there is a learning period when new hires are on their best behavior, and Seale went through this phase as well. It seemed Art's personality prevented him from developing friendships—or even working relationships for that matter. "I disliked Seale from the moment I met him," said one security colleague. The security team considered Art arrogant, pompous and short tempered. Although he had an inferiority complex about not having an education, others viewed Seale as quite intelligent. Many of his former workers don't speak highly of Seale, but it is hard to find someone who doesn't speak highly of his intellect.

Although he was not well liked by his coworkers on the security staff, for reasons many find hard to understand, Anthony Maravel liked Seale and thought his performance worthy of advancement. So, when an opening for a security supervisor position became available, Maravel pushed for Seale's promotion. If tension between Seale and his colleagues was high, this move did nothing to alleviate it. With Seale's promotion, Maravel began his usual recruitment for a replacement, reaching out to the surrounding police agencies. Several months prior to the opening, one of Exxon's executives had his home burglarized. The executive lived in Millburn—not far from Florham Park—and was impressed with the detective who had investigated the crime. The executive suggested Maravel reach out to this individual. The detective's name was Robert Crowell.

Bob Crowell was a fourteen-year veteran with the Millburn Police Department and had become dissatisfied with working in the affluent, sleepy community. Millburn is known for its Short Hills Mall and the Paper Mill Playhouse. It is one of the wealthiest communities in Essex County and is also a town with a low crime rate. For an ambitious man such as Crowell, the job was not rewarding. Crowell worked the streets for many years before being promoted to detective. Within the detective bureau, he found the work a bit more challenging despite the lack of crime there was to investigate.

In the slow-moving community, Bob Crowell stood out as a young, smart and ambitious cop who would grab a case regardless of the severity. He would work hard, spending long hours tracking down suspects to bring his cases to a successful conclusion. A college degree wasn't required to be a police officer, so most in the field were without one. Bob Crowell was one of only a handful of officers throughout Essex County with a degree. By the time Crowell was called to investigate the break-in at the Exxon executive's house, he was at a crossroads. "I was getting burned out," he said. "It was the same shit day in and day out. Locking the same people up, doing the same stuff, it was boring."

That boredom led Crowell to begin exploring a law enforcement career elsewhere. Crowell's years in law enforcement, coupled with his academic credentials, made him a candidate for federal law enforcement. However, the thirty-three-year-old detective had a small window, since the age limit for federal law enforcement was thirty-five. Crowell was in the process of making that transition, but when President Jimmy Carter put a hiring freeze on all federal jobs, his aspirations quickly ended. It looked as if Crowell was stuck in Millburn until one day when he picked up the phone and Anthony Maravel of Exxon asked if he would be interested in a driver position with the security department.

One of the first assignments Art Seale had as a security supervisor was to assist Anthony Maravel with Crowell's interview. With all three having backgrounds in law enforcement, the interview went well, and both Seale and Maravel recommended Crowell for the position. With his old position filled, Art was now able to focus his efforts on his role as security supervisor. He had never been a supervisor, so the new position brought some anxiety. He was tasked with overseeing five different New Jersey locations, including Clinton, East Millstone, Linden and two facilities in Florham Park. Not only was he responsible for ensuring adequate protective measures were in place, but he also now managed a security force consisting of forty guards. It was a challenging assignment

for him, and he needed to learn fast about such technology as closed-circuit security cameras and burglary and alarm systems.

Considering these obstacles, Seale performed quite well as a supervisor. His attitude was positive, and his interactions—as best as can be determined—were professional. For now, at least, his relations with vendors, integrators and the guards he managed were good. Now that Art's work was going well, Jackie must have been pleased. They were making good money and had left the blue-collar world behind—at least so they believed.

As the years passed, Seale's demeanor began to erode; his temper of old began to reappear. "He looked," said Bob Crowell, "like a Prince Valiant with his haircut and blue eyes," but his personality didn't align with his soft looks. Members of the security team nicknamed him "golden boy" or "wonder boy." Presumably, these nicknames were exchanged outside of Seale's presence. Soon, coworkers were on guarded behavior when he was around.

After several years at the energy company, Art was making a salary of nearly $60,000 a year. Couple this with his $10,000 pension, and he was bringing in $70,000 a year; in today's dollars, this equates to over $240,000. Factor in the money Jackie was making working for an insurance company and substitute teaching, and the two were financially comfortable.

The couple had purchased a large house in the affluent Chester Township. Snuggled in Morris County, Chester is considered one of the most beautiful towns in the state. They lived at 21 Roger's Road, which sat on five acres of lush land. They purchased the home for $46,000 right when Art acquired the job at Exxon. They had everything a couple their age could want—financial security, two healthy children and a nice neighborhood for their family. However, they "weren't content to live out the middle-class dreams of their parents and peers," said Morris County prosecutor Michael Murphy. Instead of saving and investing their money for the future, they were spending it as quick as it came in. They dined at fancy restaurants, drove nice cars, wore fine clothing and sent their children to a private school. Whether they felt a need to impress people isn't known. But everything they did aligned with looking wealthy and acting like they had more than they actually had. Their neighbors referred to them as yuppies.

Jackie was well liked and made a good deal of friends; many of whom said she was soft-spoken and a sweetheart. Art, on the other hand, was harder for others to relate to. He was intimidating and could be stand-offish. Even so, the couple mingled with neighbors, and at Christmas time, Jackie was known to bake delicious cookies to share with friends and

neighbors. To some, Art and Jackie were enjoying the fruits of their hard work. Others believed them to be very ambitious. To some degree this was true, but their ambitions weren't the laudable type. Their desire for money and material goods became irrational. This irrational behavior put them on a trajectory for failure.

Even with Art's temper showing more at work, his work ethic seemed to be good. Jackie, however, couldn't keep a job. Supervisor after supervisor quickly became dissatisfied with her performance. One such supervisor hinted at the reason for her transient job résumé: "She'd rather spend time talking than working." Their quest for wealth blurred their view of reality. With all the spending they were doing, they failed to pay their income tax obligations. The couple's credit began to decline as well, as Jackie was building debt. A sign of this was that she began using different variations of her name, applying for credit cards using her middle name of Jacqueline as her first name. Fortunately for Art and Jackie, the real estate market was thriving, and their home increased exponentially in value. The purchase of the Chester home proved to be a good financial decision, especially since they purchased it below market value. Their house was now worth double what they paid. Sitting on all that equity, they couldn't help themselves and took out an equity loan.

CORPORATE REORGANIZATION

Several years had passed since Bob Crowell left policing to work for Exxon as an executive driver. When Art Seale was promoted to security manager, Crowell took Seale's security supervisor position. Once again, his career seemed to be following Seale's. Through the years, Crowell had worked with Art but not on a continual basis; now, Seale was his immediate supervisor. Crowell had an advantage with his new position that Art had not had. As a detective, Cowell had supervised before. He had a working knowledge of leadership and management. Crowell also brought more knowledge of physical security operations than his predecessor. Crowell was trained in criminality and crime prevention techniques, which gave him exposure to security cameras and alarms long before Exxon hired him.

It was difficult for some in the Exxon security department to understand what Anthony Maravel saw in Art Seale. Nonetheless, Maravel was the boss, and he liked how Art performed his job. In fairness, the role of security supervisor was not an easy position, especially with no prior experience managing people. Seale did a good job in the supervisor role and prospered. Now, as a security manager, Seale supervised several Exxon locations and a large contingent of security officers. The role was more complex and challenging than before; besides his previous duties, he was now in charge of the mailroom and dining areas, necessitating familiarity with suspicious package identification and handling. He was also responsible for coordinating background checks on vendors.

CENTRAL FLA Cattle Ranch. 160 acs. Will trade—Current appraisal your responsibility. Previous offer not received. Call 201-404-6713

The FBI tells kidnappers it didn't receive their correspondence. *From the* New York Times *Classifieds.*

The security office at Exxon was different than the offices at the Millburn and Hillside Police Departments. Upon entering the facility, a welcoming face in the form of a secretary would greet you rather than a leather-faced desk sergeant. There was a waiting area with comfortable seating, not the hard metal chairs at the sergeant's desk. It was clear that the environment was different. The interior of the security office was sectioned off with desks, much like a police station, but with nicer office furnishings. Those of higher importance, such as Art Seale, had their own office. A conference room with a large wooden table surrounded by comfortable chairs sat not far from Seale's office. And unlike police stations, the computers had encrypted password protection and proprietary software for enhanced security protection. The well-run security department was not a "yes sir, no sir" environment, unlike the quasi-military environment of policing.

The relationship between Crowell and Seale remained professional; it never ventured into socializing together outside of the office. However, they did have law enforcement in common, and during one conversation about their previous jobs, Art pulled up his pants leg to show Crowell his eighteen-inch scar from the on-duty injury that put him on disability.

By now, Art had nearly a decade at Exxon, and his level of comfort began to reveal his true personality. "I recall," said Crowell, "many times [Seale] would be talking with his wife on the phone" and he would say "We can't do it this way," and then he would "slam his door shut." His short-tempered hotheadedness started to be on display at work. Art's underlying anger issues, which once caused him to pistol-whip a woman, were coming to the forefront. "He had pretty bad…anger management issues," said Bob Crowell. "Periodically it would flare up." Because of Seale's high-ranking position, "Nobody talked back or took him to the fence." Instead, everyone just remained guarded to prevent a volatile and explosive outburst. With his new position, he became known as a bully who could be cutthroat and vindictive. Some suggest he had an unhealthy ambition for advancement, which aligned with his fascination with money.

Crowell said Seale had told him, "I know I'm not going any further because I don't have a college education." The energy company was an advocate for an educated workforce. It wanted the "best of the best," Seale told Crowell. It was clear to Art Seale he wasn't going to receive another promotion. What wasn't clear to him was that his temperament, not his education, was to blame. "He had a reputation," said Crowell "of being a bull in a china shop," and executives were noticing, regardless of what Anthony Maravel thought.

The pressure of his new position appears to have been wearing on Seale. When an opening for training to become a pilot was posted, Art Seale applied. He was excited about the prospect. The process to get accepted into the program was intense but didn't need previous flying experience. At the interview phase for the training, Art Seale appeared before board officials. The degradation of his ability to control himself became evident at this interview. A question asked to Seale during the interview suggested that others who applied had prior flying experience. The board member asked if Seale knew "the average lifespan of a Marine Corps aviator." The question pushed Seale to lose control. He knew the board member was alluding to Seale's lack of credentials, and it angered him. "I don't know," Seale said. "Four minutes," the member replied. "I don't need this any longer," Seale told the board in a raised voice. "I'm out," he said and left the room.

When Seale spoke of the incident to Crowell, he said the board was "grilling him," and he wasn't going to sit there and "take their shit." Art felt the board members did not "know what they're talking about." Something had gone wrong in the years that had passed since he started at Exxon. Now, he was suspicious of his bosses and felt they were not giving him the credit he deserved. Because of this, he became increasingly bitter and hard to get along with. Crowell said this behavior was "very typical of [his] interactions with" Art Seale.

Seale's behavior and treatment toward other executives became appalling to watch. "He would answer them in a matter of fact way with little respect," remembered Crowell. For Arthur Seale, these men were just "guys in empty suits." He simply believed he could do their job and do it better. He always had an air of arrogance about him, which gave many he worked with the impression he thought he was better than them. Bob Crowell knew him as well as anybody at Exxon and believed Seale's arrogance came from his extremely high IQ. Crowell believed Seale's IQ had to be somewhere in the "135 or 145" range. He "was

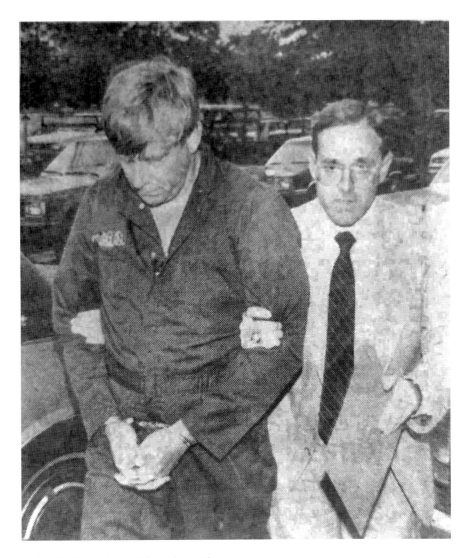

Arthur D. Seale. *Associated Press photograph.*

very, very smart...but not with people." Certainly, Seale's superiors were not blind to his attitude, behavior and the effects these had on the security workforce.

By 1985, Art Seale had had a successful career working for Exxon. However, things were changing. The Exxon hierarchy was in the process of reorganization, including the security department. It was not unusual for those within the department to wonder if this would affect their

positions. When it was confirmed that two former military men had been hired to run the department, according to Crowell, Art Seale was "not happy about" it.

As the reorganization was underway, Art and Jackie began discussing starting a business of their own. Their plan was a bold one that, if it worked out, would require them to relocate to Hilton Head, South Carolina. This business idea caused the Seales to travel to Hilton Head often and brought about a less engaged Art Seale while at work. Members of the security staff witnessed a sharp decline in Seale's work and in his attendance. He may have been ill-tempered, but he was reliable. So when he began taking vacation days to shorten his work week, everyone knew something was wrong. Then, when it began to look like he and Jackie were going to be able to make the move to Hilton Head, he began to speak of his plans to leave Exxon and to start a business in South Carolina.

The trips he was taking to South Carolina caused resentment with his coworkers and angered Seale's superiors. Fridays were normally reserved for corporate meetings and to set the next week's agenda. With Seale taking off every Friday, there was a breakdown in communication with the locations Seale was supervising. To add insult to injury, on Monday mornings, he would show up tanned and with no understanding of what the week's agenda was. When approached about his attendance, Seale seemed to care less.

Tired of his noticeable decline, a senior executive reported Seale's performance higher up the chain of command. It turned out Anthony Maravel was protecting Seale and had tried to circumvent Seale's performance from being reported. In May 1985, Art Seale was called into a meeting and was told the security department was reorganizing and downsizing, which resulted in his position being eliminated. Whether this came as a shock to Seale isn't known. He was presented with a severance package that would be paid through January 1986. Reportedly, the initial severance was not to Seale's satisfaction, and Exxon agreed to a better package.

"THE ULTIMATE YUPPIES"

Hilton Head, South Carolina, is an exclusive island town boasting twelve miles of beachfront where the rich and famous come to play. The barrier-island town covers close to seventy square miles, nearly thirty of those miles consisting of water. Here, summers are gorgeous and winters mild. Streets are lined with small boutique stores painted with pastel beach colors. Each street seems to be separated by manicured grass, palm trees or flower gardens. In season, cars idling down the streets are all upscale, with many being convertibles. The salt air is sweet and the breeze mild. This is a community many people long to be a part of. For Art and Jackie, this was the ultimate place.

Hilton Head is a community where many neighborhoods and resorts are gated and with accessibility open to only those living or staying there. Along the shoreline are several city parks that grant beach access for those not staying on the island. How Art and Jackie Seale stumbled upon this community isn't known; but it is clear they fell in love with the island. The Seales believed they could acquire enough money from the sale of their home to buy a house and business on Hilton Head.

Bill Hunter and his wife, Sally, owners of a decorating business near the entrance to the Hilton Head Palmetto Dunes Resort, had done what Art and Jackie were hoping to do. They had run a successful business on the island for years. Now, the couple were readying for retirement and were selling their business. Porter Thompson, an advertising executive and a popular island resident, was brokering the sale. Thompson had been doing so for

years. As a child, he came to Hilton Head with his parents, who owned a home on the island. In the 1970s, he moved permanently to Hilton Head and became the director of central information services for the Sea Pines Plantation Company. Along with his employment at Sea Pines, Thompson worked a variety of jobs at various locations on the island before opening up an advertising business. As a trusted businessman and islander, the Hunters hired Thompson to sell their business.

In their search for a business on Hilton Head, the Seales met Porter Thompson. He showed them a few business opportunities, and the one that resonated most was the Hunters' small storefront shop. Thompson was impressed with Art and Jackie. In the discussion phase of trying to get the Seales to purchase the business, Thompson had taken them out on a few occasions for business lunches and dinners. Through these encounters, he thought Art "considered himself a winner who wanted to look and live like a winner." Thompson believed Seale's intentions were laudable. Both Art and Jackie looked and presented themselves well. They were not short on words and were friendly enough. Thompson believed the couple, in their mid-forties with two children, had the financial standing to handle such a purchase. Because of this, he set up a meeting between the Hunters and the Seales.

On a sunny day sitting in a restaurant overlooking the salty water of the inlet, Thompson sat with Bill and Sally Hunter waiting for the Seales to arrive. When they walked through the restaurant's door, the Hunters couldn't help but be impressed. The Seales were attractive and dressed the part of a wealthy couple. The young couple reminded the Hunters of themselves. They too were young once and, like Art and Jackie, had come to the island to start a business. Porter Thompson had to see the similarities and likely used this to leverage the sale. The meeting went well and led to a series of follow-up conversations that ultimately ended with Porter Thompson sealing the deal.

The booming real estate market made it easy for Art and Jackie to sell their home. They closed on the sale of their house in September 1986 and walked away with nearly $250,000 in profit. This, and the severance package provided by Exxon, gave them a considerable amount of money in hand. A friend and Chester Township neighbor, Diane Rochelle, recalls this was a "very optimistic time for" the couple. They had spoken of an easier lifestyle centered around sunshine and palm trees. "They came to Hilton Head with a lot of money and a lot of dreams."

With their business purchased, Art and Jackie went house hunting. The extent of their aspirations can be seen with the purchase of a four-bedroom,

three-bath house with well over three thousand square feet of living space. The home sat on a large parcel of land that had an unobstructed view of Braddock Cove. Their new address would be 4 Willet Road in the private Gull Point section of Sea Pines Plantation. With large, high-vaulted ceilings, floor-to-ceiling windows, large front and back yards and a gorgeous water view, the house was built to impress. And that's just what Art and Jackie wanted to do. They were consumed with what others thought of them, and the way they dressed, acted and lived illustrates this, even if their desire to mingle with the elite was never realized. Their guests would feel the warm hospitality of their success while indulging in the abundantly green backyard of Arthur and Jackie Seale.

Driving south toward their sunny destination, the Delaware line seems to have been a symbolic divide for Art and Jackie, because they cut off all ties with the Szarkos. The couple had become pompous, and the success that they had, in their minds, was greater than what Jackie's family had ever achieved.

It was now the spring of 1987, and the couple were working hard to get their new business ready for the upcoming season. They named their store Insiders and hired several employees who had worked for the Hunters. Neither Art nor Jackie had any knowledge of decorating, which was what their store would be selling. They had a short time to learn, and they relied upon their new employees to help them prepare.

Before they could gauge what business they would attract, the couple began spending money hand over fist. They purchased elegant furniture for their home and favored eating out to eating in. Restaurants on the island are expensive, and Art and Jackie were generous tippers. Laying down large tips—in their minds—showed others their success. If they spent a lot of money while in New Jersey, that was overshadowed by what they were doing on the island. The luxurious lifestyle had become an addiction for them. If in the past they had some self-control, that was long gone. They were

Asking for proof of life once again. *From the* New York Times *Classifieds.*

immersed in the world of leisure. A his-and-hers set of white Mercedes-Benz cars was purchased. They bought a sailboat—a thirty-eight-foot cabin sloop. Closets were filled with designer clothing, and the children were sent to Hilton Head Preparatory School, costing them $5,000 a year per child.

Those watching may have though Art Seale a hedge fund manager and Jackie the CEO of a large company. But this was far from the truth. They were a couple seeking fortune with no education or particular job skill. All they had was a good deal of money made from the purchase of their home. As for their business, the season had not even started, so it was too soon to tell what sort of revenue it would bring in.

A perspective on the Seales and the lifestyle they were living is illustrated in a picture of them aboard their boat. Art is looking handsome while he is sporting an expensive white polo shirt; Jackie stands at her husband's side wearing a red shirt and a designer sweater. She is stretching her arms out and around Art's muscular shoulder. Their children, Justin and Courtney, are strategically placed in front. The image is strong and projects a well-established, prominent family.

Neighbors of the couple said it would be difficult to find anyone who didn't like Art and Jackie Seale. "She was very sweet, pleasant, kind and outgoing," recalled one neighbor. Another neighbor called the Seales "very decent people." But despite appearances, there were subtle signs everything wasn't what it appeared. "They seemed to have a lot of contempt for the people who had to get up and go to work and then do it all again the next day," said Porter Thompson. "Hell," he continued, "that sound[s] like a lot of normal people I know." The Seales made it clear to the hard-working islander that they wanted nothing of the "nine-to-five rat race." But despite this contempt for the hard-working, Thompson seemed to be intrigued by them. Or, as he once said, "I envied them. They seemed to have it all."

The misinterpretation of the couple was due to Art and Jackie telling everyone of their success and their plans. They spoke of "establishing a franchise" and bringing their company to Florida's Gold Coast. People like Ellen Cole, a business associate of the Seales, were under the impression Art and Jackie "had it all, a big house, a new boat, [and] nice cars."

Interestingly, the services they offered through their store weren't a bad choice. It wasn't the product or service that failed but the timing of the upstart business. By the mid-1980s, the economy was slipping toward a recession. By 1988, the decline of the economy impacted businesses on Hilton Head, and long-established boutiques began losing money, with some closing their doors. Perhaps the Hunters saw this coming, and that's why

The Seales. *Associated Press photograph.*

they wanted to sell their business. However, it wasn't only the distress of the economy that brought the Seales to financial ruin but their exorbitant spending and lifestyle.

Porter Thompson knew the island's economy probably better than most and said "little money was coming in" with businesses everywhere. Despite this, Art and Jackie continued to wine and dine as if everything was fine. Those a bit closer to the Seales, like their employees, began seeing signs the two were under a degree of stress. In the beginning, Art and Jackie seldom fought. Now, the two were quarreling in front of others. Moreover, Jackie's once nonchalant and bubbly personality had evaporated into mood swings. Art had always had a low flash point and during an argument at work threw a screwdriver at one of his employees. Apparently the Seales began to feel the pressure of their pending tax burden and mounting debt.

"Haunted by their own successes and failures," said Michael Chertoff, U.S. district attorney for New Jersey, they were "yuppies obsessed by their own overreaching and delusion of grandeur." The Seales left Hilton Head under the cover of darkness, stealing the unpaid merchandise out of their store. "They hurt us for a few hundred thousand dollars," said Bill Hunter.

They left owing Porter Thompson $30,000. In all, they were half a million in arrears as they drove with Hilton Head in their rearview mirror.

For reasons not understood, the couple headed to Vail, Colorado. The upscale town sits at the foot of Vail Mountain and is primarily a tourism community. When they crossed into the city limits, Art and Jackie had little money between them. Vail is a community filled with pine trees, white-topped mountains and snow-filled trails for hiking and skiing. Like Hilton Head, prominent people live here. Arriving during the summer, the Seales were able to rent a luxury condominium overlooking the exclusive Vail Golf Course. The view was breathtaking, with high mountains in the background and the finely manicured golf course in their backyard.

Somehow, despite Colorado law requiring a license to hold a stock broker position, Art secured a job doing just that. He was now employed with PaineWebber in Denver. PaineWebber happened to be the largest stock brokerage and asset management firm in the world. To say the least, the job paid well. Jackie was also quick to find employment working for a small design company that worked with the convention center in Vail. For a time, it seemed they were on the mend. Their new neighbors seemed to get the same impression past neighbors had—they were a young couple filled with ambitions. "They hoped they would soon buy the property," recalled one neighbor. However, the Seales could barely pay their rent, never mind purchase a half-million-dollar condo.

The stress the couple was under impacted Art and Jackie as parents, records indicate. Their time in Vail was a troubling period. It appears things began to unravel for their children. Teenagers often go through a difficult period when they push parents to the edge, and presumably Justin and Courtney were no different. Joe Venneman, a Vail investigator who was familiar with the family, said Courtney "did not have a good relationship with her dad." The reason for this has not been revealed and could very well have been part of Art's continued anger issues. It was said that in his anger he would shout at his kids and was, at the least, verbally abusive. On at least one incident, police responded to the Seale home on a report of domestic violence.

There is little documentation on the time Arthur Seale spent under the employ of PaineWebber. It is known that he began working there in July 1989 and "voluntarily" terminated his position in January 1990. Jackie's poor work ethic continued, and she was fired from her position. "I let her go," said Susan Brody, Jackie's supervisor at Convention Designs. "She just wasn't the right one for the job. She was a very talkative person, particularly talkative," Brody said.

By the spring of 1990, Art and Jackie could no longer continue with their charade. They had failed. Their aspirations didn't match their work ethic. They wanted much without having to work hard. Neither Art or Jackie had a degree of talent worthy of the money they sought. With financial ruin, there was nowhere else for them to turn but to their parents. First, Jackie asked her mother if they could move in with her. Her mother told Jackie she did not want Arthur in her house "controlling everything."

"THE SEALES OF POSSOM HOLLOW"

The Seales had hit rock bottom—and it was a hard fall at that. Gone were the affluent towns of Chester, New Jersey, Hilton Head, South Carolina, and Vail, Colorado. Gone was the thirty-eight-foot sailboat. Gone were the private schools for Justin and Courtney. Now they and their children were living with Art's parents.

Somehow the Seales felt jaded. They did not look inward at their overspending and exorbitant lifestyle as a contributory factor toward their ills. Rather it was the economy that was responsible for their financial ruin. But it wasn't just that—it was Exxon! He had been an able and reliable employee for the energy company and it let him go without a thought.

As for Art's father, after years of dedicated police service, neither he nor his wife, Daphne, could have imagined having to support his son and his family. However, as parents, there was nothing they could do but assist Art and his family.

The elder Seales had left city life behind in the hopes of settling down in the countryside. The concrete office buildings of Hillside were replaced by the green mountains of Washington Borough. Upon purchasing their home, they hung a large wooden sign at the foot of the driveway at 201 Musconetcong River Road that read "The Seales of Possom Hollow." Although misspelled, the pride they held was evident. The house sat far off the road, and at the tail end of their property flowed the Musconetcong River. The Seales had replaced the sounds of cars passing by with the soft tones of a flowing river. Fishing was something the elder Seale enjoyed

doing, and with the river in his backyard, he didn't have to wander far to cast his line. Fortunately for them, they had enough room for Art, Jackie and the grandchildren.

As for Art and Jackie, their disdain for middle-class living came back to haunt them. The houses on Musconetcong River Road were average in size and scope. People here were blue-collar workers—some would call them rednecks. Art had referred to these types of people as "poor saps." And although Art and Jackie felt themselves above those living on Musconetcong Road, the neighbors here seemed to like the

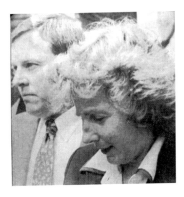

Ed Petersen escorts Jackie Seale. *From the* Star-Ledger.

younger Seales. "My kids went to school with their kids," neighbor Richard Goerner said. "I used to see the Seales jogging along the road all the time." Another neighbor described Art and Jackie as "lovely people."

It's hard to imagine the impact the constant moving from town to town had on Art and Jackie's two children, Justin and Courtney. Despite this, the two seemed to be doing fine, and it appeared some of the problems they had in Vail were dissipating. Possibly Art and Jackie controlled their fighting, making for easier home life, or maybe the children were now under the influence of their grandparents. Maybe it was because they were now in public school and had more in common with the children there. Regardless, for a little while, it appeared things had settled down.

Pride is a stubborn thing, and Art and Jackie were having difficulty dealing with the situation they found themselves in. They were simply humiliated, even more so after the belittling attitude they blatantly displayed while they were doing financially well. Now, living in a child's room in his parents' house, accounts suggest Art was angered and blamed his situation on Exxon. It seemed each employment rejection he received fueled his resentment towards the energy company. Not helping matters, Jackie was able to gain employment while he failed at each attempt. However, Jackie was disingenuous to her employer, Matt Mattarazzo, telling him that Art worked for Exxon and Jackie could bring in important clients. Mattarazzo, who owned a winery, said Jackie "had great ambitions" and said the job was "a temporary thing" for her. She just needed something for the short term until they could get their affairs in order. Interestingly, in one conversation Mattarazzo had with Jackie, she mentioned that she and Art were planning

to move to a tax-free place like the Virgin Islands. There, she said, "nobody would know her." Although Mattarazzo thought Jackie to be nice and friendly, he fired her three months later because she failed to live up to her offer to bring clients in. In the three months under his employ, she did not bring in a single account.

For years, the Seales had not paid their taxes, and by the spring of 1991, that had caught up with them; the federal government put a tax lien against Arthur Seale and Jackie for nearly $7,000 in unpaid personal income taxes. If they thought their troubles in South Carolina were behind them, they were sadly mistaken. A judge there cast a judgement against the couple for $35,000.

The downward trajectory for Art and Jackie continued into 1992. Art had found employment for a security company in New York City making $40 an hour, but for unknown reasons, this work was short lived. What work Jackie was able to secure was also short lived. It seemed she could not maintain employment for any period. In February, Jackie was in the running for a position to head the chamber of commerce in Washington Township. The likelihood of her obtaining the position was promising, as over forty people had applied for the position and she became a semifinalist for the role. During the process, Jackie interviewed well and apparently was perceived as intelligent and cheerful, but a bit chatty. Unfortunately, she failed to get the job offer and was told someone more qualified got the position.

For Arthur and Jackie Seale, each passing day seemed to bring new financial heartache. They were running out of options to recover from what they had originally viewed as a temporary setback. And yet they were obsessed with material things. They believed they were entitled to a better life than what they were living. By now, the two were irrational with dreams that exceeded reality.

THE PINE BARRENS

The spotted lines on the black pavement were mesmerizing as they drove on the long and shifting roadway. Traffic was light, as the late afternoon rush had come and gone. Darkness had fallen, and Art knew he had to be alert and attentive. He couldn't afford to be stopped by police during his nearly two-and-a-half-hour drive. And with light traffic, troopers certainly were looking for speeders taking advantage of the open road.

The northern portion of the Garden State Parkway cuts through the urban areas of Newark, Irvington and Union City. When not looking for drug dealers or other types of criminal activity, the state police vigorously enforce the motor vehicle laws. As a former cop, Art Seale was well aware of the state police's reputation. Under most circumstances, if stopped, Art would flash his police badge and a trooper would likely not issue a summons as a professional courtesy. However, this was no normal circumstance; Seale had a dead body in the trunk. An overabundance of caution was needed for them to achieve their objective of delivering the body to a shallow grave in an isolated area of South Jersey.

Driving a rented Chevy Lumina—with the corpse of Sidney Reso rolled up in plastic in the trunk—the Seales had to wonder what went wrong. They had planned the kidnapping for months. It was supposed to be their meal ticket out of poverty. Yet there they were transporting a dead body. However, in their minds, it was no fault of their own. It was not their actions that caused Reso's demise, it was the events that followed. And, after all,

if Exxon had not mistreated him, Art wouldn't have been prompted to his evil deeds. The Seales reasoned it was Sidney Reso's actions that led to him being shot and beaten. As the tires rolled down the macadam, the Seales were blinded by greed and desire and were out of touch with reality. Not a rational or self-reflective thought was present within the cold confines of their automobile. They "wanted a shortcut to the sort of affluence Exxon International President Sidney J. Reso had earned in a lifetime of hard work and sacrifice," said Michael Chertoff, and they weren't going to let a thing like Reso dying stop them from getting their money.

The car's headlights illuminated the green parkway sign framed in white for Exit 58 as Art steered onto the exit ramp. He turned north on County Road 539 and drove into darkness. There were no stores, no office buildings, no homes and no street lights. There was nothing! Their car lights were the only thing keeping darkness from enveloping them. They drove about a mile and a half before turning down a dirt road. They were in Bass River State Forrest, and this dirt road lead them deeper into the dense woodland. The thick trees on each side of the road covered the narrow path like a canopy.

Art was taking them deep into the Pine Barrens, to a spot where few people ever wander, especially at this hour. The location was perfect! There was no better place to dispose of a body than the New Jersey Pine Barrens. And the night was cooperating. The cloud cover was thick, shielding the moon and making the night even darker than he had hoped for. Folklore speaks of the Jersey Devil lurking in the dense forest. It is said that a Pine Barren witch long ago gave birth to a child whose father was the devil himself. The child "changed to a creature with hooves, a goat's head, bat wings, and a forked tail," reports a Wikipedia page. Immediately after changing its form, the child killed the midwife and flew off into the pine barrens. It is believed that the Jersey Devil still roams the dense forest looking for prey. The Jersey Devil is not the only resident of the barrens. People known as "Pineys" live here, too—people whose births haven't even been recorded. They live off the land. They are not part of civilization. Some say they aren't friendly to those visiting their land. It is stories like this that keep many away from the Pine Barrens. Few if any would muster up the courage to enter at night.

As they crawled along the bumpy dirt road with Reso's body thumping in the back, the pathway thinned to where the car just barely fit the road, causing brush to rub up against the side of the vehicle. When Seale believed they were in deep enough, he stopped the car. Then he got out and popped the trunk, and he and Jackie carried the body down off the trail into the thick brush and woodland. "I helped Arthur bring the body wrapped in

Media's insensitivity. *From the* New York Post.

plastic" out of the trunk, said Jackie. They were surrounded by silence. Not even a cricket could be heard. The air smelled of garbage due to dumped trash nearby. This was just the start. They still needed to carry the body deep into the woodland, far removed from the dirt road and any path people may traverse. Seale was going to make sure that when the body was buried, no one would find it.

The couple dragged the body nearly three quarters of a mile down an overgrown tick-infested path. Once Seale found the location he was comfortable with, he told Jackie, "Get back to the car." She looked at him with disbelief. It was dark, and she was afraid. "I'll come and meet you when I'm done burying the body." Art didn't want to "leave the car by the side of the road." He knew the state police patrolled the area, and "If they see an abandoned car, a trooper will come out and investigate."

Jackie had no choice and returned to the car. She then left the area and drove around, periodically circling back to where they had stopped. She realized she needed to observe some landmarks so she didn't get lost and paid particular attention to a discarded refrigerator not far from where they had dragged the body down into the woods. With each pass, she had to

wonder why Art was taking so long. But it was laborious work digging a grave deep enough to ensure the site wouldn't be uncovered by animals or noticed by anyone hiking by. Art was making sure that when he placed Reso in the grave, there he would remain.

With ticks crawling up his leg, Art Seale dug the grave three feet deep, eight feet long and five feet wide. He was winded and tired but labored hard to get the body into the ground as quick as he could. Once the hole was big enough, he rolled the body into it. The thump was deadened by the thick pines. He covered up the grave and walked the long stretch back to the dirt road.

A GOOSE CHASE THROUGH
THE MORRIS PINES

THURSDAY, JUNE 18

The sounds and chatter inside the command post didn't damper the ringing of the phone. "Hello," said the female agent, acting as if a Reso family member. "Money, ready?" The voice on the other end said. It was Art Seale, disguising his voice. "The money is ready," the female agent told the caller. She continued: "If you'll please tell me where you want us to take it, we'll take it." Silence filled the phone line. Then, Seale responded by saying "shortly." The agent knew the longer she could keep him on the phone, the more likely the call could be traced. "Shortly?" she responded back in an inquisitive tone; but it was too late, Seale had already hung up. The agent wrote the time of the call down—2:55 p.m.

By this point in the investigation, Walker had been running nightly surveillance details on every phone booth in and around Morris County. Upwards of 240 law enforcement officials were out each and every night with the hopes of spotting the kidnappers. The investigation showed that each call the kidnappers made had come from a phone booth. There was no reason to believe they would change that method of operation.

With that phone call, authorities had another shot at the kidnappers. Over a month had passed with no contact whatsoever from them. Now, with agents spread throughout Morris, Hunterdon, Warren and Union Counties, Walker and his team were sure they would spot the culprits. The money

exchange would run the same as the first night they thought the money would change hands. A SWAT agent would be tucked in the back of the money car, which Ed Petersen would be in. And as before, SWAT agents would shadow the car. Once again, the car was going to be Patricia Reso's personal vehicle. A coat of ink only visible to agents high above was painted on the roof of the car.

Unlike the first night agents thought they were going to do the exchange, the money car would not have the $18.5 million in the back. By now, the FBI was reasonably sure Reso was dead; several opportunities had been given to the abductors to provide proof of life. "This was an obstacle," said Ed Petersen, "they simply couldn't get over." So agents rolled up old newspapers and put them in the Eddie Bauer bags. Tonight, the FBI was playing hard ball. The kidnappers requested Patricia Reso be in the money car to assist Jim Morakis with the delivery. There was no way Walker was going to risk her safety by putting her in that car.

Theresa Riley was around the same age as Sidney's daughter Renee, so when the kidnappers called again, agents told them Renee was filling in for her mother because Patricia was too distraught to participate. Ed Petersen had successfully pulled off being Jim Morakis—the entire time the kidnappers thought they were speaking with Morakis, they were talking with Petersen. They would do the same with Theresa Riley. In fact, Theresa had spent the past two weeks with Renee going over every little detail of her life. Theresa needed to memorize as much as she could about Renee and her family. The junior agent couldn't have imagined just a few years since joining the force that she would play a significant role in the largest ransom request in U.S. history.

This case had taken a toll on everyone, from the police on the street to the agents behind the desk. Everyone was on edge. With the call that came in earlier, Cottone was excited. "My intention was to be in the car," he said. "I was in the car on the previous [ransom] night," and so it was natural for him to believe it would be the same this night. However, Walker didn't see it that way. There would be three people in the car: Ed Petersen, Theresa Riley and SWAT agent Tony Backus, secreted in the back seat. This hit the agent hard, but he figured Walker would place him in the field as part of the support team. This wasn't in the operational plan either. Cottone was instructed to remain inside the command post and provide support to those in the field. "I was a little ticked," said Cottone. "This is the end of the fifty-day affair, and I hadn't taken one day off." Not being part of the operation was demoralizing.

Earlier on, when communication between kidnappers and law enforcement had stopped and the case went cold, Tom Cottone asked that his role as case agent be turned over to someone else. "I wanted to keep active on the investigation," Cottone said, "but felt I couldn't do so as case agent." This case was so large that the administrative tasks alone were consuming his time. Taking that away, he thought, would free him up to concentrate on the investigation itself. Cottone was one of the few agents familiar with the North Jersey area, so it made operational sense for Walker to keep Cottone inside the command post to help direct the money car from location to location if necessary. Some suggested that keeping Cottone inside was bureaucratic payback for relinquishing case agent status. Either way, Cottone had a strong sense of frustration as they waited for the kidnappers' next call.

LATER THAT NIGHT

With the sound of chicken grilling and an aroma of garlic and onions drifting under their noses, Ed, Theresa and SWAT agent Tony Backus sat in the living room running over in their minds the night's operation. "We went over what to expect," said Theresa, and "did some role playing. Ed was getting us geared up and ready to go out there." Part of this preparation was going over "scenarios if this should happen, what they would need to do," said Theresa. Running through what-if scenarios is crucial in law enforcement, especially in operations such as this.

Standing over the stove in the kitchen was Patricia Reso. She was cooking for the men and women she had gotten to know. She worried for her husband and her children, but she worried also for those brave officials about to embark on a dangerous mission. She certainly had to hear the agents talking about the possibility of an ambush. She knew these individuals were risking their lives to bring back a person none of them had ever met. They were extraordinary people, and a plate of warm food might calm their nerves and give them the nourishment needed for the night's mission.

In case the kidnappers were watching the Reso home, it was necessary for the money car to leave from there. So a small contingent of officials once again occupied the residence. Some agents sat in the formal dining room at the large table, while others mingled around. Backus and Petersen stood closer to the kitchen "going over how they were to handle things if

Art Seale. *FBI SIDNAP media file, from an unknown newspaper.*

something happened," said Theresa. After discussing matters with her counterparts, Theresa Riley took a position in a large leather chair in the living room. There, she sat alone and didn't utter a word. She was busy listening to others engrossed in conversations. Theresa had a great deal of responsibility resting on her shoulders. Not only did she have to convince the abductors she was Renee Reso, but she would also be driving. For a young agent, this had to bring a degree of anxiety. If something went bad, it would be her job to drive them to safety or to get them to a place of cover.

After Backus and Petersen were done going over the night's plans, Backus went outside to meet with the SWAT group to review the shadow operation. Ed Petersen, on the other hand, began walking about the home and speaking with each agent to calm his nerves and to ensure his team members remained calm as well. Most in the room would be in support positions, which meant Petersen and those in the car with him would depend upon them if things should go bad. Ed also made sure to spend time with Patricia Reso to calm her nerves and to thank her for the meal and the hospitality she and her family had provided to them.

After agents finished the chicken and rice Patricia had made, the mood in the home changed. The chatter became lighter in tone. Theresa chose not to eat. "I needed to stay focused" she said. As a firearms instructor, Theresa knew she would be more mobile and tactical on an empty stomach.

Hours had passed, and the enticing smell of simmering food had dissipated. The food had long been digested, and minutes began to feel like hours as they waited for darkness to fall. It went without saying that the kidnappers were going to operate under the cover of darkness. The waiting was excruciating for the agents. What Patricia and her children were feeling as they waited is unfathomable.

9:08 P.M.

Out of the silence in the room came the call they were waiting for. Before picking up the ringing phone, a radio transmission was broadcast to agents in the field advising them of an incoming call from the kidnappers. Hopefully, the kidnappers would use one of the booths agents had under surveillance. The female agent picked up the phone. "Hello," she said. "Leave now. Go to Tingley Road at Patriots Path. Look on the ground, envelope!" The agent tried to keep the kidnapper on the line: "Where on the ground, can you tell me?" Seale replied, "Envelope on the ground," and then hung up.

According to Gail Chapman, the kidnappers' "plan fell through right there." The Seales planned on sending agents to several locations on a wild goose chase with the goal to lead the money to the Gladstone train station for the 10:09 p.m. train. There, agents would be told to take the money on the train. Seale would have them drop a bag off at each of the train's stops. This, Arthur Seale believed, would exhaust the surveillance teams, eventually leaving a bag or two on the train for them to pick up without the worry of a surveillance team waiting for them. It turned out the Seales "didn't leave us enough time to go place to place," said Chapman, who was now the case agent.

Eleven minutes after the call concluded, Ed Petersen, Theresa Riley and Tony Backus pulled out of the Reso garage. "This is it," said Theresa. Those in the car were heavily armed. Ed had his .40-caliber Glock tucked into his waist band, while Theresa was carrying a nickel-plated .228-caliber handgun and a 4-inch Smith & Wesson revolver. Lying between the two agents was a pump shotgun. In the back seat, Tony Backus lay under a tarp. Tucked next to him was a fully automatic long rifle. As they traversed the long driveway Sid Reso had driven prior to his disappearance, they couldn't help thinking of the man. Theresa turned right onto Jonathan Smith Road heading in the direction of Tingley Road and Patriots Path in Lewis Morris Park. From here on, it was Ed Petersen who would be in charge, speaking directly with the kidnappers under the pretense that he was Jim Morakis.

The night was dark, with a cloud covering the pale moon. The temperature was mild, lingering in the mid- to upper sixties. This allowed Theresa to keep the windows down, so she could hear what was going on around them when they were stopped. Tim Quinn and Brian Doig helped provide directions to Tingley Road via an open phone line to the money car. "Brian knew the area like the back of his hand," said Theresa. With each turn Theresa made, a radio transmission was generated informing surveillance teams of the car's

movement. "We knew we were being surveilled by SWAT team members," said Theresa. Even though she didn't see anyone as she drove, she knew "they were there."

They were barely off Jonathan Smith Road when the cellular phone inside their car rang. "Go to Patriots Path, look for an envelope for instructions," Art told the man he believed was Jim Morakis. "We're en route," said Ed Petersen. "We got your directions and…and we're… we're en route right now. We're making the turn. Can you please repeat everything so it's clear to us, okay?" Seale's response was short: "Tingley Road, Patriots Path." Playing his role to perfection, Ed Petersen said, "Just bear with us because we're not used to doing this. We're a little nervous."

9:33 P.M.

Exxon ID photograph. *From the* Star-Ledger.

As Theresa neared Tingley Road, the car's headlights illuminated the large, wooden Lewis Morris Park sign, the wood aged and the colored letters faded. She turned onto the dirt road and stopped near a park bench. Darkness enveloped the area, and Theresa couldn't hear a sound. "We are stopped," Backus whispered over the radio to the surveillance teams. Speaking of the incident, Theresa said the "car's in neutral. I'm ready to move"—leaving the car in neutral left her a notch away from reverse or drive, depending upon what was needed. She continued, "Eddie's out" of the car and "every second I'm talking to Tony," telling him what is happening. Backus couldn't risk leaving his position under the tarp. Theresa had to be the eyes and ears while Petersen was out of the car. Over the radio, the surveillance team advised them they were watching. "I know they're there," she said, even though she didn't see them. "That's how good they are."

Once Petersen found the note, he returned to the car and read it aloud: "Drive west on Route 24, 5.3 miles to Ralston General Store. Further instructions to be found on bench in front of store. Follow directions precisely. Proceed at normal speed." Ed verified over the open phone line that the

surveillance team had heard where they were going and then nodded for Theresa to drive.

Tim Quinn and Brian Doig knew exactly where the money car needed to go. The Ralston General Store was actually a museum; it hadn't been a general store since the late 1700s. It was in an isolated area rarely patrolled by police. Theresa was told the directions the kidnapper provided were good and to proceed slowly to allow the lead vehicles to get in place before she arrived. At each stop sign or light, Theresa would stop, and either Brian or Tim would tell her to turn right or left or proceed straight. "You have to remember," said Theresa, "I had no map. I had no GPS. I was relying on the eyes and ears of those in the command post." And assuming she was being watched, she needed to look as if she was lost and not driving slow deliberately. The young agent played her part perfectly, pausing here, slowing there and stopping as if confused or lost. It was all an act and performed pretty well.

9:50 P.M.

Outside the general store, Ed spotted the envelop sitting on the bench and grabbed it. Once again, he read the note aloud so those in the command post could hear what it said. "Go 3.9 miles to the Williamson Building." There were two bushes by the entrance; "on the hedge to the left, you'll find an envelope with additional instructions."

And so Theresa did her driving routine again, turning the car slowly around in the parking lot of the general store. Just prior to pulling out of the lot, the cellular phone rang, but the call was quickly dropped. "We were unable trace it," the command post advised. Three minutes later, the phone rang again, but the call was quickly disconnected. However, this time they were able to trace the call to a pay phone at the Elks Club in Gladstone. There was a surveillance team near that location, and they were sent to see if they could spot the kidnappers. However, when the team arrived, the kidnappers were gone.

9:56 P.M.

As Theresa drove slowly through the dark country roads, she spoke their location so surveillance teams knew where they were. Theresa could hear indistinguishable chatter on Tony's radio. He was busy coordinating his SWAT units. Meanwhile, Ed Petersen sat quietly staring out the windshield as the car moved along.

10:07 P.M.

The phone resting on Ed Petersen's lap rang. "Yes," he said. It was a woman who was clearly disguising her voice. "Hurry, Hurry!" Petersen could hear in her tone that she was frustrated. "Okay, we're hurrying. Just give us a chance," he said. "We're doing the best we can." There was no response. It was clear the kidnappers had a timeline that they weren't keeping up with. The call could not be traced.

10:09 P.M.

Tim Quinn and Brian Doig "weren't familiar with the Williamson Building, and there seemed to be some confusion inside the command post," said Theresa. Because of this, it "took a while to find it." When they finally did, Theresa pulled alongside the curb in front of the large white brick structure. The place was well lit, and a few cars could be seen driving by. While Petersen walked the long path to the front door, Theresa filled Tony in on what she saw around them. Backus couldn't risk even moving an inch, since their location was well lighted. When Petersen returned, he read the note:

> *Continue west on Rt. 24 for half a mile, turn left on Rt. 206 for 3.6 miles, to second traffic light, turn left onto Holland Avenue for approximately .2 miles, turn left to unpaved stone driveway for the Komline Sanderson Company plant. Directly ahead is a phone booth. Wait for a call. Be there before 10:00. Mrs. Reso must answer the phone. Will ask her questions and give further instructions at that point.*

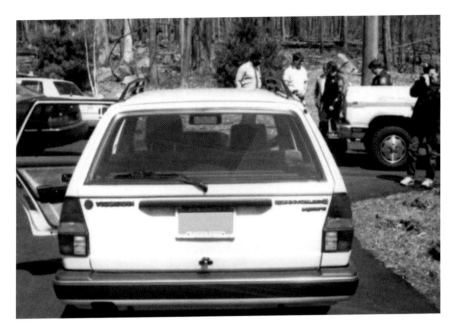

Crime scene picture of the back of Reso's car. *FBI crime scene photograph.*

As they drove, the cellular phone rang, with Theresa answering the call for Ed, who was on the phone with the command post. "Who is this?" Art Seale asked. "I'm Renee," responded Theresa. "Okay, what is your address in Houston?" Seale had asked a question to which Theresa did not know the answer. She remained silent and looked over at Ed for guidance. Thinking quickly, Petersen grabbed the phone and said, "Look, Renee is nervous and just wants her father back." There was no response, and then the line went dead. Ed and Theresa looked at each other, wondering if the kidnapper had bought their excuse.

10:40 P.M.

Pebbles cracking under the tires could be heard as Theresa pulled onto the unpaved driveway of the Komline Sanderson Company. "It was kind of an eerie location," said Petersen. "Because it was open, and they had these big bins where they had gravel and sand and all kinds of products that you'd find to fill the roads." The property was large, with little lighting to fill the space.

They spotted a phone booth sitting in the shadows off in the distance near an old building. A "dimly lit bulb" illuminated the interior of the booth, said Petersen. The booth sitting in the darkness looked odd. As Theresa drove in, the thought of an ambush was clearly on her mind. "Anyone under this circumstance," she said, "would be nervous. But knowing the surveillance team was out there, and I'm amongst the best, was comforting."

Theresa cautiously approached the booth as Ed peered around looking for signs they were going to be jumped. As she crept closer to the booth, they could hear the phone ringing. She pressed the gas paddle to get to the phone, kicking up rocks under her tires, then skidding the car to a stop so Petersen could jump out to answer it. "Ed was a tremendous athlete," said Theresa, and his speed getting to the phone was amazing. However, when he picked it up, the line was empty. They had hung up.

Petersen looked toward Theresa with a degree of frustration. Then the phone rang again. As she watched Petersen on the phone, Theresa notified the command post that Ed was speaking with the kidnappers. The command post notified the agents in the field to "watch the phones." The kidnappers told Petersen to leave the property and they would contact him on the cellular phone.

Miles away, FBI agent Kerry Bryzenski was sitting in her car and noticed a man on a payphone she had under surveillance. The man was of average height and a bit on the beefy side. Bryzenski watched as the man walked to the phone and initially thought nothing of it because he seemed fine. However, when the radio transmission came through that the kidnappers were calling, she took a closer look at the man. She watched and waited. Then, when the command post advised the call had ended, Bryzenski noticed the man had hung up the phone. She watched as the man slowly walked to a large garbage can, took off what appeared to be rubber gloves and discarded them in the trash. The agent then watched as the man walked to a white Cutlass Ciera tucked in the shadows nearby. She could see that another person was in the car, but couldn't tell if it was a man or a woman. As the car drove out of the lot, she wrote down the license plate number, HJR-41U.

The plate was run through the National Crime Information Center database and came back to Betty's Rent-a-Car at 141 Mountain Avenue in Hackettstown, New Jersey. Sitting in the command post, Walker and Cottone discussed what to do next. "I'm monitoring all this," said Cottone, "We said, let the car go, we have surveillance, and planes up." With that decision, the agent let the car roll out of sight. "With all the law enforcement

out there, we could have invaded a small country," said Cottone. "We didn't know where Sid was…so we would follow the car."

The command post was busy, with radio transmissions sounding, phones ringing and people talking. In addition to Tom Cottone, Tim Quinn and Brian Doig, John Turkington and several other agents were in the command post to work the leads that came in. Betty's Rent-a-Car was one of them. They would need to go up to the car dealership and try to obtain who the vehicle was rented to. "I called a friend," said Rich Riley. "He had a used car lot in Hackettstown." It was likely he would know who owned Betty's. As expected, the man did, and he provided the owner's name and her Roxbury Township address. Roxbury Township Police were called and asked to pick the woman up and bring her to her business, where agents would meet with them.

The operation was immense, and the geographical difficulties were expanding. "Where the kidnappers and surveillance teams were," recalled Cottone, "had to be twenty-five miles in the opposite direction of the command post. Betty's had to be twenty or more miles in the opposite direction of us." Basically, the "kidnappers were in one direction, the command post in another and Betty's in another." John Walker looked at Cottone and said, "I want you to go to Betty's, take another agent and a few people with you. Find out who rented the car." As luck would have it, Steve Foley had just walked into the command post to begin his overnight shift and was put on the detail.

Cottone wasn't happy he had to leave the command post right in the middle of the operation, especially since they had identified a person of interest. He believed his skills would be better served assisting with what was unfolding in the field. And, to be fair, he wanted to play a little part when an arrest was made. But he was given an order, and he followed it.

Agents Tom Cottone, John Turkington and Joseph McShane, along with Steve Foley of the Morris County Prosecutor's Office, headed out to meet with the owner of the rental car company to find out who rented the car. If successful, they would then call a judge to get a telephonic search warrant for the renter's house.

Ed Petersen and Theresa Riley were driving around as instructed, waiting for a call to come in from the kidnappers. Meanwhile, Art and Jackie were trying to decide what to do since they had missed the 10:09 p.m. Gladstone train. Their best shot for getting away with the money was to get it on a train. Art knew FBI agents were out there; he may not have known the man he had been talking to was an agent, but he knew the bureau was involved.

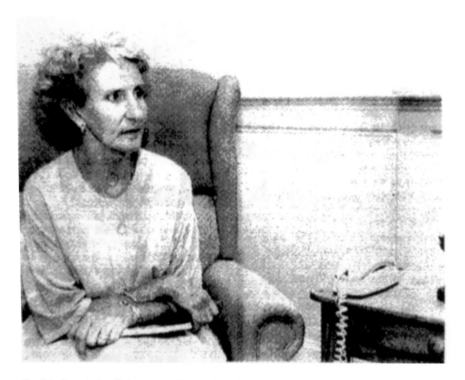

Patricia Reso in her living room. *From the* Star-Ledger, *photograph by Robert Eberle.*

The Seales needed to be smart with their next move. Art pulled out a train schedule and noticed that a train was set to arrive at the Far Hills station before midnight. He dropped Jackie off at her Mercedes with instructions to go to the Somerset Hills Elks Club, call the cellular phone and give them directions to the Far Hills station.

10:59 P.M.

Knowing that Jackie was going to redirect the money car, Art called the cellular phone. "Go back to the other phone. Hurry back," he told Petersen. The call was traced to the Gladstone Sunoco gas station. Once again, agents arrived too late. With the instructions to head back, Theresa turned the car around and drove to Komline Sanderson. There, at that dimly lit phone booth, they waited.

11:11 P.M.

FBI agents watching the Somerset Elks Club observed a white Mercedes pull into the lot. The white female driver got out of the car and used the phone booth there. No call came to Petersen's phone, so agents documented the incident on their log but didn't think much more of the woman. That woman—Jackie Seale—was calling her husband and not the money car. She was asking him what he wanted her to do next.

11:16 P.M.

The FBI agents surveilling the Somerset Elks Club spotted the white Mercedes driven by the same woman pulling into the lot once again. She made another call. The agents checked with the command post, who in turn checked with Ed Petersen to see if a call came in from the kidnappers. Petersen advised he was not in contact with them, and agents again just entered the incident on their patrol log. This time, Jackie was calling Art for directions on where he wanted her to tell Morakis (Petersen) to bring the money.

11:21 P.M.

From a location unknown to officials, Jackie called the phone booth at the Komline Sanderson property. Ed Petersen picked up the phone. "Return to Route 206, make a left on Route 202, make a right on Whitenack Road," she told him. "Leave money on east side of railroad crossing." Petersen started to say "Okay," but before he finished, Jackie changed her mind and said to drive to the Far Hills train station by Whitenack Road. They were to "await a call there."

11:28 P.M.

Arthur Seale pulled his rented car into the Far Hills train station and turned off his headlights before bringing the vehicle to a stop. His actions were

Art Seale in his Admiral Farragut Academy uniform. *FBI SIDNAP media file, from an unknown newspaper.*

observed by a surveillance team sitting in the parking lot. The train station was well lighted, and the surveillance team was able to get a good visual of what Seale looked like. They radioed his description as "a white male, blond hair, pot belly, 230 to 250 pounds, wearing dark-framed glasses, white denim pants, and a blue short-sleeve shirt." His attire was not what agents would have expected from a kidnapper; even on a night when he was extorting money, Art Seale felt the need to dress preppy.

The team watched as Seale got out of his car and slowly walked to a location where he was no longer visible to them. They waited, and two minutes later, they saw him appear out of the shadows returning to his car. Seale then left the parking lot and, according to the radio transmission, "drove west on Route 202." Agents were told not to follow, as another surveillance team nearby would pick up the car. However, the surveillance team was unable to locate the car, and Seale seemed to disappear into thin air.

It is certain Seale spotted the surveillance team, because from this moment on, his actions were evasive, and he clearly had aborted his attempts to receive the money.

11:53 P.M.

Another surveillance team spotted a Cutlass Ciera traveling west on Route 640 in Basking Ridge. However, the team was not certain it was the suspect's car, because they were nearly an hour from the Far Hills train station. The unit made a hard U-turn, caught up to the Ciera and realized the license plate was that of the suspect's car.

The car was followed west on Route 640 until Art Seale observed a police roadblock at the intersection of 640 and Route 613. The roadblock had nothing to do with the kidnapping operation; it was the sheriff's department conducting a sobriety check point. However, Seale did not know this and turned sharply in the road to head in the opposite direction. He drove so fast that the surveillance team was unable to keep up, and they lost him.

12:50 A.M.

Miles away, officials arrived at the rent-a-car facility. "We get [to Betty's] about quarter to one," said Steve Foley. Pulling into the lot, Foley looked around. He noticed the building was constructed in an L shape. Foley took note of a car parked out front. The parking lot was poorly illuminated by a small light on the right corner of the building. When he and the other agents got out of their cars, they noticed the front door was padlocked shut. "We're knocking on the door," said Cottone, but "nobody is there." They had thought the local police and the owner would have arrived before them, but this was not the case. So they began to mill around, killing time. "In the corner of my eye," said Foley, "I see this guy standing there." That was odd, and the guy "looked real hinky." As Foley stood watching, the man turned and walked out of sight behind the building. "Hey, what are you doing?" Foley shouted. What Foley didn't know is that man was Arthur Seale. Seale ignored Foley and walked quickly to his car.

As this was happening, Foley looked to see where his counterparts were. They were off in the distance and didn't see what was transpiring. On his own, Foley pursued the man around the corner and saw the guy getting quickly into a car. "What are you doing?" Foley asked again. Realizing he couldn't ignore Foley any longer, Seale responded in a casual voice, "I'm returning a car I rented." Foley paused for a second. It was not unusual for a person to be dropping off a car after hours. But it didn't feel right to the lawman, so he visually inspected the car. "I looked over at the plate and it's the plate we ran," he said. Bingo! What are the odds, Foley had to think to himself.

Knowing now that he was talking with a suspect, Foley moved closer and engaged the man in conversation. While he was doing this, John Turkington came around the corner and spotted Foley talking with the man. Turkington glanced to a car a few feet away and noticed the vehicle was being backed out of a parking space by a white woman. Turkington, wondering what was happening, looked at Foley. Foley nodded his head at the moving vehicle. John Turkington knew exactly what Foley was saying—that car needed to be stopped. Turkington then ran over to the car and prevented the woman from backing out.

Before Foley could walk over to him, Seale got into his car. Foley identified himself to Seale and instructed him to exit his car. One can only imagine what was going through Art Seale's mind. When Foley got Seale out of the car, he searched Seale for weapons. There were none. Just as he completed

his search, Tom Cottone and Joe McShane came around the corner. Both lawmen quickly realized their two counterparts had discovered two people of interest. Cottone then gave the car a closer visual inspection. "There's the car with the tag we were looking [for]," Cottone said.

Realizing Foley had the suspect standing right in front of him, Cottone walked over to the two. "I'm an FBI agent," Cottone told Seale, "What are you doing here?" Seale looked at him, trying to maintain his composure and hide the worry creeping down his moist spine. Seale had been through this before, but never on the receiving end. With a slight smile on his face, he responded, "I'm just returning this rented car." Seale then looked over toward the car Turkington had stopped and said, "that's my wife over there." Since Foley patted Seale down he knew he was weaponless and left McShane and Cottone to interview him. Foley then worked to render assistance to Turkington.

Tom Cottone followed up with his previous question—"Oh, where were you?" Seale knew the game. All he could hope for was that this agent wasn't sharp, and he could talk his way out of a terrible situation. "We went out to dinner." His tone, to an untrained person, may have suggested he was telling the truth. However, his body language and eye contact told a different story. Cottone built on this and didn't respond immediately to Seale's answer. Silence filled the darkness around them in the parking lot. Then, the agent spoke. "Okay sir, I need to see your license and registration, so I know who I'm talking with."

Seale was too slow in retrieving his paperwork, which caused Cottone to become inpatient. "You don't mind if I look through the wallet," the agent said while taking it from Seale. "No," Seale said as the wallet changed hands. A tarnished police badge inside was hard to miss. The agent thought to himself how he had suspected almost from the beginning that the kidnapper might have been a cop. Now he was speaking with a man who had a Hillside Police badge in his possession. "This was a complete role reversal," said Cottone—the man he was speaking with was on the other end of the questioning, and Cottone knew that had to cause angst to him. Although he didn't say so, Cottone had Seale under arrest. He was not free to go. Under normal circumstances, when a person is not free to go, their Miranda rights (the right to remain silent and have an attorney) apply, but in this instance they did not apply. A less seasoned cop might not have known better, but Cottone knew he had exigent circumstance. Sidney Reso was still missing, and regardless of the likelihood of him being alive, the possibility still existed. He needed to find out all he could from the ex-cop standing before him.

With Seale's wallet in his hand, a series of questions were asked.

"Is this your address?" Cottone said, pointing to Seale's license.

"Well, that's where I'm staying," said Seale. "That's my parents' address."

"You're living with your parents?"

The agent could see Seale was embarrassed, and he wanted to build a rapport with Seale, not shut him down. So he brought the conversation around to a topic Seale might feel comfortable with.

"Are you a cop?" Cottone asked.

"No, I used to be a cop in Hillside," Seale said with a noticeable sigh of relief.

"Really, I used to teach at the Essex County Police Academy," said Cottone.

"I could have had you with one of my classes," said Seale.

Seale in his jail garb. *Associated Press photograph.*

"Probably," said Cottone.

"My father was the deputy chief."

"How come you left the department?

"I got injured in a car accident and got a disability pension from the department years ago."

Cottone's strategy was working; Seale had calmed down and seemed more relaxed. Now Cottone wanted to get some answers related to Reso's kidnapping.

"Just out of curiosity, do you have any pets?"

"Oh, yes," said Seale.

"What kind?" asked Cottone.

"I have a golden retriever."

"That's nice," said Cottone.

What the agent was doing was checking off boxes in his head. The BSU said the kidnapper was likely a police officer or someone familiar with policing. Check! The forensics showed the kidnappers' letters had dog hair in them, likely from a golden retriever. Check! The BSU said the letters were written by a man and a woman. Check! Steve Foley and John Turkington were speaking with the woman just a few feet away.

"Do you have any children?" asked Cottone.

"I have a son and a daughter."

"What did you do after you left the force?"

There was a pause. Seale knew his answer would lead to additional questions. Seale didn't know why the authorities were at the rental place. Possibly they were there for something unrelated to his night's activities. Or so he hoped. However, he needed to answer the question.

"I went to work, for Exxon security in Florham Park."

"That's nice," said Cottone. "Where in Florham Park?"

"Oh, right at the headquarters."

The gig was up, and in Cottone's mind, it was time to switch his tone.

"Let me tell you why we're here," asserted the agent. "We're looking for Sid Reso. He's been reported missing."

"Yeah, yeah," Seale said. His body language indicated Cottone hit a nerve. "I heard all about that. I've been talking to my friends at Exxon security."

Cottone just stood there looking at the man. Not a word was uttered. Then Seale broke the silence.

"They have been telling me they're getting all this overtime."

"Let me tell you something, Arthur, Sid is not missing, he's been kidnapped, and you did it! Where is he?" asked Cottone.

"I don't want to talk to you," Seale responded, now with a facial expression of contempt.

"I'm going to tell you something," Cottone said in a raised and angered voice. "If he's been kidnapped and you did it, anything you say can be used against you." There was no need to say anymore. "You understand your rights?"

"Yeah, I do."

"Where is he? He's been kidnapped, and you did it. And I know you did it."

Now it was Seale's time to just stand there and not say anything. Silence once again filled the void between the two men.

"If he's alive, that's the best thing that can happen to you," Cottone said. "If he's dead, we want him back."

"I have nothing to say to you," said Seale.

"I have something to say to you," Cottone said. "You're under arrest."

As Cottone and Seale were navigating through conversation and questioning, Steve Foley and John Turkington had been speaking with the woman in the other car. She was nice looking and spoke with a soft tone. Her skin was white and was more noticeable in the dark. "Stop the car," were the first words Turkington said to the woman. Next, he told her to "turn off the ignition and exit the car!"

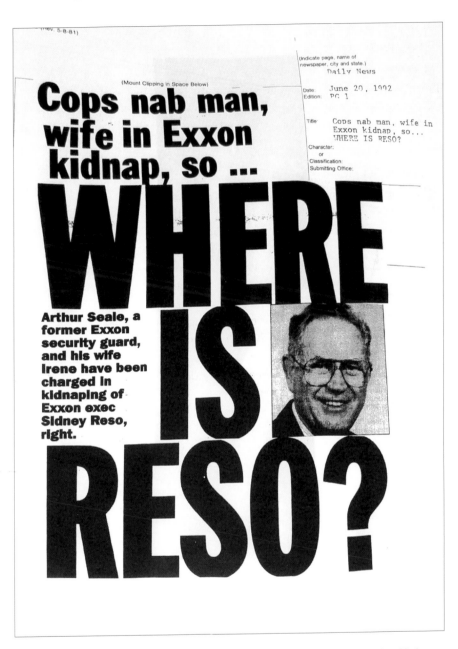

FBI clippings of *New York Daily News* headlines. *FBI SIDNAP media file, from the* New York Daily News.

Unlike her husband, she had never been through this before. It was scary, especially knowing what she and Arthur had been up to. She complied and stepped out. Her slender figure was noticeable as she got out of the car.

Turkington said, "I conducted a protective search for weapons." She had none on her. Turkington asked what her name was, and she said "Jackie Seale." Turkington then asked for her identification so he could verify what she said was true. She pointed to her pocketbook on the passenger's seat. Turkington reached into the car and retrieved the pocketbook. Inside, he found a wallet with her driver's license. He asked why she was in the parking lot so late at night. Jackie said they were returning a car they had rented. She looked over at Seale and said, "That's my husband." When asked what they had been doing this evening, she said they were out with a "group of individuals." Since the night ended earlier than expected, they decided to return the rented car so they didn't have to do so in the morning. However, she said, when she and Arthur spotted them in the lot, they thought the agents looked suspicious, and that's why they were leaving.

As they spoke with her, Jackie avoided giving a specific location where they had been. Somehow, the conversation turned to her daughter. Her voice indicated she was nervous and seemed to tremble more while speaking about her children. She started to air some of the problems she was having with her daughter. "It was sad," said Turkington about having to listen to her. She obviously realized she had been caught and her actions would take her away from her daughter and her son.

Jackie was asked if she knew anything about the Sidney Reso kidnapping, and she said she did not. She then abruptly asked to speak with her husband. "I asked her," said Foley, "if I can look inside of her car." Jackie looked at him and didn't say a word. "I asked her again," said Foley, "and she said, 'go ahead.'" Popping the trunk, "I saw a couple things," Foley remembered. "Tupperware containers, sheets of plastic, gloves and a lock." The items were questionable, but "seeing that there was no body, I closed it up."

With Seale under arrest and his car searched, Cottone walked over to Foley, Turkington and the woman. By now, Jackie was sitting on the curb, and John Turkington was standing alongside her. "I'm Tom Cottone," he told Jackie. "Listen! I'm telling you Sid Reso is kidnapped. You are involved with it and so is your husband." She did nothing but look up with defeat on her pretty face. "Your life, as you know it, is now over," Cottone told her. Tears began to form under both of her eyes. "Are your kids involved? Because we have to investigate everybody here." This was a statement made to induce a response from her—a motherly response of protection. Possibly it would

make her cough up information to exonerate her children. The defeated look on her face turned to anger. She didn't utter a word. "You think about that," said Cottone. He paused for effect. Silence is a very effective tool. "If you want to cooperate, now is the time….Our investigation centers on you, your husband, your kids and your golden retriever." Although the look on her face indicated to Cottone that "she was on the verge of cooperating," she did not and remained silent.

Finally, the local police and the owner of the rental place arrived. They confirmed with the owner that Art and Jackie Seale were the only people associated with the rented car they had surveilled. A phone call was made to the command post to tell them they had two people under arrest.

In the dead of the night, the agents headed back with their prisoners. As they navigated the dark country roads, Tom Cottone reflected on the evening. It had been a roller coaster ride of emotions. He couldn't have imagined that the supportive role he had been vehemently opposed to would lead to him taking part in the actual arrest of the abductors. However, he had conflicting emotions. "I did not know if I made the right call," he said of arresting Seale. They still did not have Reso, and if others were involved, retaliation was a possibility.

POST ARREST

EARLY MORNING, JUNE 19

Art and Jackie were brought in for arrest processing. Theresa dropped Ed Petersen off at the police station to interview the Seales. Shortly thereafter, she was advised to return to the command post, where she would be part of the team that was going to raid the Seale residence.

An emergency search warrant for Seale's parents' house was granted, and the operation was going to be a large one, including Agents Joseph Vidovich and Theresa Riley, Detective Steve Foley and Detective Brian Doig. Although it was early in the morning and everyone had been up all night, it was necessary to hit the house without hesitation and with the crew who had been working the case most intimately. As far as Walker and his team knew, there could be more people involved. They needed to move quick—if there was any chance that Reso was alive, speed was a necessity.

The sun was barely over the treetops when the contingent of police vehicles sped down the driveway of 201 Musconetcong River Road. The porch light was on, but it appeared everyone inside was still asleep. Several agents and officers went around back to ensure no one ran out while agents were going through the front door.

First through the door was Agent Joe Vidovich with the team on his heels. Agents ran from room to room with guns drawn. Arthur Sr. and Daphne were beside themselves. Standing in their pajamas, they wondered what

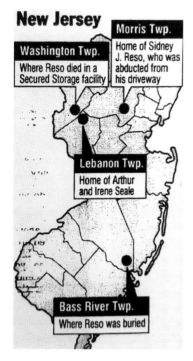

New Jersey

Morris Twp.
Home of Sidney J. Reso, who was abducted from his driveway

Washington Twp.
Where Reso died in a Secured Storage facility

Lebanon Twp.
Home of Arthur and Irene Seale

Bass River Twp.
Where Reso was buried

Map highlighting the Seales' crime trail. *From the* Star-Ledger.

was happening. Arthur had never been on this side of a raid before. One can only imagine the disbelief they felt when agents advised them their son was under arrest for kidnapping and their daughter-in-law was an accomplice. "It was horrible," said Foley, "Watching a man who spent a career as a cop having to go through this. He was a really nice guy."

Most of them knew the likelihood of finding Reso alive was nil, but there was still hope. Not long into the search, it was evident that Sidney Reso was not there. Now it was a mission to find proof they kidnapped him and evidence to help determine where he was.

Significant evidence was uncovered that lent itself to greed as a motive. "We uncovered information," said Foley, "about processing money in the Cayman Islands [and] travel information." It was not unusual—most kidnappers are motivated by money. However, sometimes revenge can also play a part in a kidnapper's mind. The documents found suggested Art and Jackie were hellbent on criminality. Art's book collection included *Manhunt*, about the Unabomber; *Violence in Latin America*; *Complete Book of Contemporary Crime on the High Seas*; and *The Secret Money Market: Inside the Dark World of Tax Evasion, Financial Fraud, Insider Trading, Money Laundering and Capital Flight*. A considerable amount of information on foreign banking and how to set up overseas accounts was recovered, and nearly a dozen guns were confiscated.

Meanwhile, at the Morris Township police station, Ed Petersen and John Turkington weren't having nearly as much luck. Art Seale was tight lipped, only giving up his biographical information for the arrest report. They weren't going to flip Seale, so Ed Petersen headed over to where Jackie Seale had been brought. There, he joined Gail Chapman and Brian Doig with their interview. Sitting with the others in a semicircle across from Jackie, Petersen realized she was not a typical criminal. How she got here didn't figure well in anyone's mind. She was a mother of two, a school teacher and,

by neighbors' accounts, a very nice and friendly woman. Yet there she was staring at three FBI agents and not cooperating. Weighing on each agent's mind was the question where was Sidney Reso?

"This family has endured a horrific situation not knowing whether her husband is alive or the four children if their father is alive," Ed Petersen told Jackie. There was silence. She didn't say a word, but the look on her face indicated, ever so slightly, compassion—or if not compassion, at least sympathy. "All I'm asking," said Petersen, "[is] to tell me if he's dead or alive." As he spoke, Petersen looked Jackie in the eye. Apparently, the eye contact was too much for her. She "dropped her head towards the table," said Petersen. He knew he had hit a nerve. "I gently picked up her chin and asked, should I be looking for someone who is dead or alive?" For a moment, silence filled the room. Then, in a soft tone Petersen described as a whisper, Jackie spoke: "Probably dead." Petersen knew she couldn't bring herself to say it. Sidney Reso was dead. Now the question was what did they do with the body?

Several key pieces of evidence were found in the envelopes sent by the kidnappers. Petersen was now going to try and link the evidence to Jackie and her husband. "Do you have a dog?" he asked. "Yes," she replied. "What kind?" Displaying a little smile thinking of her pet, she said, "A golden retriever." Petersen couldn't help but notice Jackie's hair was bleached blond. Forensics had indicated that in one of the envelopes was a strand of bleached blond hair. Then, Jackie had a change of heart and stopped cooperating. "Can I speak with Art?" she asked. Petersen didn't know what to say. The interview was paused, and Ed, Gail Chapman and Brian Doig huddled together in the next room discussing whether or not they should grant her request. "What do you think?" asked Ed. "I think it's a mistake," said Brian Doig. "Why?" asked Ed. "I think this guy has a strong control over her and I think if we allow her to speak with him, she will remain silent." Petersen knew Brian Doig was a crackerjack detective and had a good perspective on people. He concurred with Brian's assessment, as did Gail.

7:00 A.M.

If Tom Cottone thought his shift was over, he was mistaken. Walker asked him to lead the team delivering Seale to the bail hearing at the district court in Newark. He wasn't the only one exhausted—the whole team working

the case had been going for more than twenty-four hours. "Somebody had to bring them to court," Cottone said to himself. Cottone shot home, freshened up and put on a suit and tie. By the time he arrived in Newark with his prisoner, scores of reporters were waiting. It had only been a few hours since the arrest, but word spread like wildfire through the news media. "When I walked Seale into the court," said Cottone, "there was a blaze of photographs and microphones in our faces."

The Seales appeared before federal magistrate G. Donald Haneke with public defenders Chester Keller and Sally Ann Floria representing them. As Jackie sat waiting for the hearing to start, she looked over at her husband and mouthed the words "I love you."

The U.S. attorney for New Jersey, Michael Chertoff, adamantly opposed setting bail for the two accused. "FBI agents," Chertoff declared, "searched the home where the couple were staying in Lebanon Township [and] found a list of banks in Switzerland, India and Pakistan with their telephone and

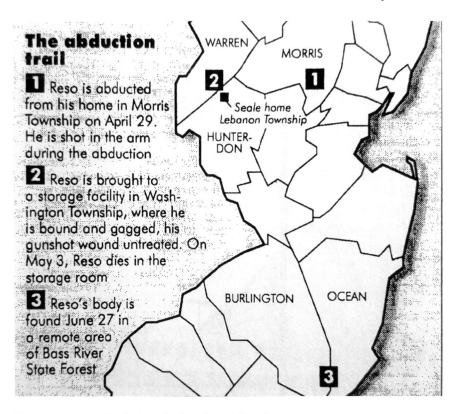

The abduction trail

1 Reso is abducted from his home in Morris Township on April 29. He is shot in the arm during the abduction

2 Reso is brought to a storage facility in Washington Township, where he is bound and gagged, his gunshot wound untreated. On May 3, Reso dies in the storage room

3 Reso's body is found June 27 in a remote area of Bass River State Forest

WARREN
MORRIS
Seale home
Lebanon Township
HUNTER-
DON
BURLINGTON OCEAN

Three key locations in the investigation. *From the* Star-Ledger.

telex numbers [and] a book that promised to reveal 'the dark world' of money laundering and capital flight." Chertoff indicated their guilt was evident. "The two hadn't a nickel between them but were looking at Swiss bank accounts?" Chertoff said in a strong and resolved tone. He told the court that journals about kidnappings and books including *Executive Protection Program: Kidnapping and Extortion* were also discovered. As part of the law enforcement community, Chertoff had contempt for bad cops. He knew the judge would too and made it clear that Seale was once a police officer. Seale wore a badge and took an oath to protect the citizens of the state. After being hurt on the job, he retired and worked as a security manager at Exxon. This, too, was a position of trust. Then, Chertoff was meticulous about the details of the kidnapping and explained everything to the judge, especially the letters indicating Art and Jackie would kill Seale if authorities didn't cooperate. He was sure to point out that, although the Seales were standing before the court, Sidney Reso was still missing.

The arraignment ended with Haneke denying bail "because of the violent nature of the crime…and the risk that they would try to flee the country."

1:00 P.M.

Agents moved fast. They discovered the rental unit—number 619—at Secure Storage in Washington Township and searched it under the rule of exigent circumstance, meaning they did not need a search warrant. Jackie's statement of "probably dead" provided the exigent need to open the shed immediately without having to draw up an affidavit. Once it was clear Reso was not in the unit, a federal search warrant was requested so forensics could sweep it for trace evidence.

"MYSTERY OF KIDNAPPING UNRAVELS"

Four days had passed since the arrest, and authorities were no closer to finding Sidney Reso than they were before the arrest of the Seales. By now, they were sure Art and Jackie were the only ones involved in the abduction. However, on the outside chance they missed something, the investigation continued into the possibility of accomplices. At a press conference, U.S. attorney Michael Chertoff said they were at a "sensitive point [and] Mr. Reso is still being sought." Chertoff emphasized that the investigation was still continuing.

Art Seale remained resolutely silent. Jackie was close lipped and insisted on speaking with her husband. "Kidnapping or Murder? Suspects Are Silent" was the headline in the *New York Times* after the arraignment of the Seales. "Nearly two months after his disappearance, the whereabouts of Sidney J. Reso, the 57-year-old president of Exxon International, remains unclear," asserted the journalist who authored the article. Sadly, the FBI knew this to be the truth. Despite having two people in custody, the agents had no idea what had happened to Sidney Reso. As Walker and Petersen were trying to figure out how next to proceed in the investigation, federal and state officials were discussing how to prosecute the case.

Under federal court proceedings, sanctions are stricter, due to fixed sentences that offer no parole. If Reso was discovered to be dead, then the state might want to prosecute the case, because New Jersey has the death penalty for murder. At this point, there was enough independent evidence that a crime had taken place, even though the whereabouts of Sidney Reso had yet to be determined.

```
{rs. Reso,

From the main entrance to Lewis {orris Park on Rt 24 drive
West on Rt 24 5.3 miles to the Ralston General Store, (historic,
on right opposite Roxiticus Road)  Further instructions on bench
front of store.

You will be observed during this delivery process
Follow all directions exactlay and proceed at normal speed
with no delays.  You must reach certain.locations by the
appropriate time.
```

Typed directions found in an envelope. *Confidential source.*

As investigators dug deep into the Seales' background, John Turkington and his partner, Agent Brady Orsini, went to Hillside to interview Jackie Seale's mother, Irene. The two agents entered the tree-lined neighborhood of Westminster, turned onto Revere Avenue and parked their car directly in front of the large redbrick Colonial. The house had an attached two-car garage and a large backyard that was fenced in. A large oak tree shielded the two lawmen from the bright sun. Irene Szarko greeted the two agents at the door. It was uncomfortable for them, because they knew she, like Seale's parents, was beside herself with what was happening. It was hard to imagine what she was going through knowing her daughter was involved in a kidnapping and likely a murder.

As they sat at the kitchen table, she offered to get them something to drink, but they declined. Turkington could tell by speaking with her that she "was a good, hard-working woman." The two agents conducted the interview in a conversational tone so Irene Seale would feel comfortable. They made it clear they wanted to glean as much as they could about her daughter.

As expected, she was distraught and couldn't believe her daughter had committed the crime she was accused of. "It was a horrific situation," she told the agents. The distressed mother was sixty-seven years old and said she had lived in her home for forty-two years. Sadly, her husband, John, had passed away twelve years ago. She was living alone and working as a per diem nurse. Now, she worried about her daughter and what was going to happen to her two grandchildren.

As she spoke about Jackie, she explained how Arthur and Jackie met and how Arthur convinced Jackie to elope against the better judgement of her and her husband. After Arthur and Jackie were married, the young couple moved in with her and John. "Jackie," Irene said, "had some issues," and

Arthur was manipulative and aggressive and would "fly off the handle" over minor things. Irene said she "witnessed several incidents in which Arthur became angry and yelled." His behavior "went beyond standard discipline methods." At one point, she said, she had to tell Arthur to "leave the children alone." As the agents sat listening across the large kitchen table, they learned that Arthur had strong control over Jackie. Irene said Arthur was "bright" but he had to "control everything. Arthur always made the decisions for Jackie in any family situation.…Because Arthur always tried to control every situation," Irene often argued with her son-in-law, she advised Turkington.

Turkington then asked about Exxon. "Arthur said he quit his job at the Exxon Corporation because he did not get a promotion that he expected," said Irene. She did not find this unusual because it "was consistent with his short temper." Afterwards, Irene spoke of the failed business Jackie and Art had in South Carolina. The business went bankrupt, and Art and Jackie lost their home to foreclosure. She spoke briefly of when Jackie and Art moved to Vail and the couple's return to New Jersey. They were broke and had only Art's monthly pension coming in. On their return to New Jersey, Jackie asked if they could move in with her, and she refused. Irene didn't want her son-in-law in her home controlling everything and everyone. This left the Seales having to ask Art's parents if they could live there. Interestingly, Irene said, "about two weeks ago," she and Arthur had a conversation where she "asked Arthur about the case since he used to be a security employee at Exxon." She figured he would have some insight into it since he once worked there. Arthur's response to her was short; he simply said "he had no details on the matter."

When the interview concluded, the troubled mother and grandmother was happy with the professionalism of the two agents. They made a difficult situation just a little bit easier to get through. John Turkington gave her his card, saying, "If you have additional information, or need anything, give me a call." Two days later, Turkington received a call from Irene Szarko. She was frustrated. She told the agent she had tried to see her daughter and was denied after standing in line for five hours at the Union County Jail. Turkington told her he would try to see what he could do to help. "If I can see my daughter," said Irene, "she's a good girl, she'll tell you everything." Irene believed she could get her daughter to cooperate, but in order to do that, she needed to see her.

Turkington hung up the phone and called Ed Petersen. Petersen, as a senior agent, seemed to know every law enforcement official in northern New Jersey. "I told Ed," said Turkington, "what she told me." Petersen

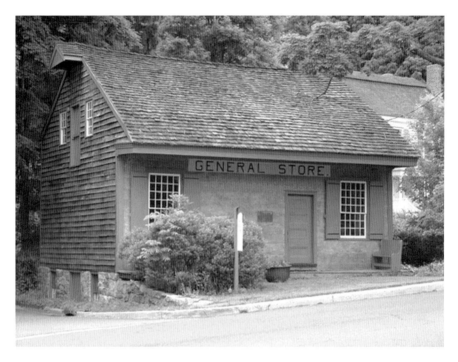

The Ralston General Store. *www.ralstonmuseum.org.*

seemed encouraged by this and called Irene Szarko. "I missed a day's work," Irene told Petersen. "If you promise to get me to see my daughter, I promise I'll get her to cooperate."

Petersen asked himself if this could be the turning point in the investigation. If so, he needed to move fast. "I called up the warden," said Petersen. "His name was Fitzgerald, and he said, 'tell her to call me when she gets here, and I'll make sure she sees her daughter.'"

"DEAL STRUCK IN KIDNAPPING"

As promised, Irene Szarko arrived at the jail, and the warden had planned for her to meet with Jackie. Sitting in a large room with painted cinderblock walls and uncomfortable chairs, Irene had a heart-to-heart conversation with her daughter. She raised her better than this, mother reminded daughter. Irene knew Jackie knew better and was a nicer person than the media was portraying her to be. Irene couldn't help but believe Jackie was under the spell of her husband and his manipulation; that could be the only reason for her participation in this horrendous act. Then, the mother reminded her daughter of the children. If she wanted to see her children again one day, she needed to cooperate with the FBI.

Days later, defense attorney Sally Ann Floria, who was representing Jackie, reached out to the FBI indicating her client desired to strike a plea arrangement for her cooperation in their investigation. State and federal prosecutors agreed that if Jackie cooperated, she would be allowed to plead guilty to lesser charges of kidnapping. "Under the agreement, Mrs. Seale could go to prison for up to forty years," said the prosecutor. "That term could be reduced if she cooperates fully in her husband's trial."

In preparation for his interview of Jackie Seale, Ed Petersen decided it would take place outside a jail or police setting. He believed a comfortable setting like a living room would be best, so arrangements were made to secure two adjoining hotel rooms to conduct the interview. There, Jackie could get a brief repose from jail and could spend a night sleeping in a comfortable bed under the watchful eye of the FBI. The interview team would consist of

Agent Gail Chapman, Detective Sergeant Brian Doig and Ed Petersen, who would lead the interrogation and take the formal statement.

Their efforts proved worthwhile, as Jackie felt comfortable and was ready to cooperate. Sitting in cushioned chairs in a living room setup, the three officials began the interview. It was question driven but also took on a conversational tone at times. The first question was "Is Sidney Reso alive?" Sadly, Jackie's response was "No." All three law enforcement officials were seasoned and basically knew what the answer was going to be, but still, it hit them hard. A feeling of sadness came over them. They felt horrible for Patricia Reso and her children. And they felt sad for the man they had never met but had gotten to know in detail. He was a good man who was deprived of the dividends of a life's hard work.

The interview produced a ten-page transcript of unbelievable content outlining the Seales' scheme, "how it evolved, and all the practice runs they had leading up to the kidnapping," Petersen recounted. Without a hint of remorse in her voice or on her face, Jackie spoke of how they kept Sidney Reso locked in a box in the back of a storage shed. She didn't exhibit sadness for the crime; if she felt sadness at all, it was likely attributed to a life away from her children. The kidnapping had been planned for months. They looked at several Exxon executives before deciding Sidney Reso would be the focus of their plot. Jackie told Petersen that Reso was selected because of his daily habits and predictable pattern of behavior. The other Exxon executives they had looked at were unpredictable and not as easy to target. Once Sidney Reso became their focus, they followed him for months, learning as much about him and his activities as possible.

Jackie told Petersen that Art was familiar with Exxon manager Victor Samuelson's kidnapping and used that as their blueprint. They would operate under the guise of the Fernando Pereira Brigade of the Warriors of the Rainbow to throw authorities off. That, Jackie said, was the reason they used newspaper ads for communicating. The demanded $18.5 million and request of $100 denominations were taken directly from the Samuelson kidnapping. They simply upped the ante because of Sidney Reso's position. Jackie said Art had a "conversion chart and knew how much money would fit in each bag." Even the wooden box came from how Samuelson had been returned. If investigators did their research, as Art knew they would, the similarities should steer authorities in the direction of an environmental extremist group and away from them.

The interview then turned to the day of the abduction. Jackie explained she kicked the newspaper to the opposite side of the driveway

The cat and mouse trail. *From the* Hunterdon Review.

knowing it would cause Reso to get out of his car. When Reso got out, she pulled the rental van alongside his driveway, and Art jumped out and forced him with a handgun into the van. However, when Reso got to the van, he saw the wooden box they were going to put him in and panicked. He then resisted, and a fight ensued, with Art accidently shooting Reso. Once they got him into the box, they duct taped his eyes, mouth and arms and then padlocked him inside. Jackie described their actions in an emotionless manner. Reso, she said, "begged them to cut off his watch, because his arm had swollen" from the gunshot. She said, they "cut off his watch and his suit and shirt sleeve to provide first aid to his wound." When they were done, "He begged us not to put him back into the box," saying he would do whatever they wanted. When it was clear they weren't going to listen, he asked again, but Art "ignored his pleas." Jackie concluded by saying Reso was kept in the box in the back of the storage shed throughout his captivity.

On Sunday, May 3, when they went to the storage facility, they discovered Reso had died. "Art had tried to revive him," she said. "But I knew he was dead.…We then proceeded to lay black plastic on the floor of the storage facility.…We took him out of the box, took off his clothes and put them in a garbage bag. He was left with just his boxer shorts." They wrapped Reso up in the plastic bags and placed his dead body to the side. Then, Art drove to his father's house to get a chainsaw to cut up the box. They placed the cut-up wood, metal hinges and locks into construction-grade garbage bags and loaded the van with the bags, leaving only Sidney Reso's wrapped body off to the side. Then they drove to their home. While Art was burning the cut-up wood and clothes, Jackie "was preparing dinner…with the understanding," said Petersen, "that they were going to collect the money later that night." After dinner and ensuring their children were in for the night, the couple headed out to demand the ransom. Jackie said when she called the phone at Villa's Restaurant, James Morakis didn't answer. Petersen was confused, as he was the one waiting for the call, and it never came. "We were there," Petersen told her. As they worked through what happened, it was revealed Jackie had a mild form of dyslexia and mixed up the number sequence. Ed Petersen had finally gotten the answer to why they never called—the kidnapper dialed the wrong number.

Jackie said that the next morning, they rented a car and put the body of Sidney Reso in the trunk. They then buried the body in the Pine Barrens. The agents knew the Pine Barrens were vast. Could she locate the body if taken there, they asked? She was reasonably sure she could.

Then Jackie was asked why they sent the money car to various locations? She explained it was to give the impression the kidnappers were watching. The "plan was to get [the money car] to a train station and then divide and conquer." Art knew they would be under FBI surveillance, so "he was willing to sacrifice a few million" to deplete the law enforcement resources. When the money car arrived at the train station, a letter would be waiting instructing those carrying the money "to take the next eastbound train with the money and the telephone." The plan was that, while on the train, they would be told to drop a bag off at each stop. They knew the FBI "couldn't leave a bag abandoned and would have to have someone watch it." In doing this, FBI and law enforcement officials would have to exhaust their manpower to watch each abandoned bag, which would deplete their resources, leaving the Seales to walk away with a bag or two for themselves. Listening to the plan, Petersen knew it was a good one. However, he said they made a mistake when they did "not allow enough time to go from location to location in order to make the train."

"UNMITIGATED EVIL"

Before daybreak, John Walker, Ed Petersen, Tom Cottone, Brian Doig, prosecutor Michael Murphy and a contingent of other officials arrived at the Union County Jail to pick up Jackie Seale. Their mission this day was to bring her to the Pine Barrens with the hopes of recovering the body of Sidney Reso. "We went all the way down the parkway," said Tom Cottone, in a convoy of official vehicles. The ride was long, and some of the officials had never been to this part of New Jersey before. The Pine Barrens cannot be imagined without seeing them. The vast region is filled with green pine trees, most of which block the sun's rays from illuminating the ground below.

The motorcade turned off Exit 58 about an hour after sunrise. They headed north on County Road 539 and didn't see a store, a house or a person. There was nothing but pine trees on each side of the road. The area was completely barren, like the name suggested. Jackie remembered driving a mile or so north after getting off the parkway when they came upon a dirt road. "We get there," said Cottone, and "she's not sure where exactly it was." It had been dark the night Art and Jackie drove down the road. She didn't realize how many dirt roads there were.

Ed Petersen, who was driving the car Jackie was riding in, pulled to the side of the road. He told her to take a moment to try to think of that night. Jackie said she "remembered walking in the woods and seeing a refrigerator." The contingent of cars spread out and began taking the various dirt roads in hopes of finding that refrigerator. It took many twists and turns before a

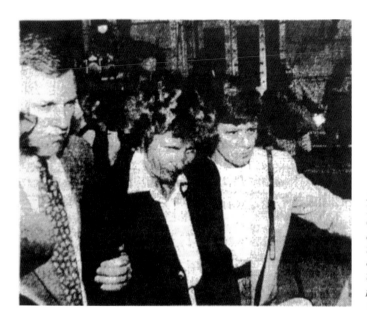

Agents Ed Petersen and Gail Chapman escorting Jackie Seale into court. *From the* Star-Ledger, *photograph by Pim Van Hemmen.*

car found a rusty old refrigerator sitting barely off a dirt road. Jackie was brought to that location and confirmed that was the landmark she had used the night they buried Reso.

After determining approximately where they stopped and took the body into the woods, the group of law enforcement officials spread out in several directions looking for signs of the grave. "There's a certain crime scene you're looking [for]," said Cottone. "You're looking for disturbed grass, brush," that sort of thing to indicate the ground has been disturbed. Before heading into the woods, Petersen asked Jackie if she was sure this was the area. "I'm pretty sure," she said. "I helped him bring the body" into the woods.

Walking down the thick and thorny brush, "probably 15 yards from the trail," recalled Tom Cottone, Jackie told them she believed they had arrived at the place they buried the body. "She's right," said Brian Doig. As a homicide detective, Doig was well versed in these types of matters. "Why is that?" one of the officials asked. "I think this is the area," Doig said to Ed Petersen. Petersen looked at the area as Brian spoke. "If you look at all the shrubbery around this area, the surrounding area is all growing vertically. This area has been disturbed. These plant roots and vegetation are growing on an angle." Sure enough, Brian Doig was right. Looking at it through his perspective, the other officials could see what he saw. Then Cottone happened to look at two nearby pine trees and observed that dirt had been thrown up against the bark.

Once they were sure the area was disturbed, they radioed the state police to bring the cadaver dog to their location. When the trooper arrived, his dog sniffed the area and "laid down right between these two pine trees....We figured that's where Sid is," said Cottone. Standing before what they believed was the grave of Sidney Reso, they noticed the area was tick infested, and they had the black creatures crawling up their socks and legs. "The prosecutor… wanted to start digging," said Cottone. but he was advised they couldn't do so until the state medical examiner arrived. The prosecutor quickly realized the agents were right.

While they were waiting for the medical examiner, "we started taking measurements to determine what town we were in," said Cottone. "Initially, we thought we were in Ocean County but weren't actually sure, so we started pulling out maps and charts to determine…where we were. It was determined we were about 100 yards into Monmouth County."

Once Dr. Robert Goode, the state medical examiner, arrived, they began digging for Sidney Reso. With defense attorneys watching, they needed to be extra-thorough in their recovery process, documenting each step in writing and with photographs. The "defense attorneys wanted everything documented.…Rarely do you have a defense attorney [present] when you're digging up a body," said Cottone.

"Every piece of dirt," said Cottone "was dug up and sifted to ensure they didn't miss any piece of evidence." It was a painstaking task. "We then got to a point," said Petersen "where you could see the image of the body in the sand." Pictures were taken. Once the scene was documented with photographs, Tom Cottone bent down and picked up Sidney Reso's left hand, which still bore his wedding ring. Cottone, a fingerprint expert, looked at the victim's hand and observed that the "fingerprints were still in good shape." He conducted a preliminary examination of the victim's prints and "could see the fingerprints were a match." After fifty-eight days wondering where Sidney Reso was, they were looking at his remains.

Once the grave was fully examined for evidence, the body of Reso was removed and brought up the path into a waiting medical examiner's hearse. Prior to closing the door on the hearse, Tom Cottone took off Reso's wedding ring, placed it inside a zip-lock bag and slipped it into his pocket.

RIVER SEARCH

As the Pine Barrens search was unfolding, agents and police officials secured an additional search warrant for the Seales' backyard and the river adjacent to the property. The warrant was secured based on information Jackie Seale provided about her husband destroying evidence by burning the wooden box and Reso's clothing in a clearing in the backyard near the river. She also said that Art threw the metal hinges, nails and locks into the Musconetcong River.

Arriving in the early morning hours, a group of law enforcement officials descended upon the Seale residence. Detective Steve Foley, Agent Vidovich and a dozen more officials, many of whom were scuba divers, told Arthur Seale Sr. of their intentions by presenting him with the warrant and began their operation.

Steve Foley took comprehensive notes on the operation, indicating the discovery of the clearing where Seale set the evidence on fire. The site, fifty-one feet from the river, was noted as the "burnt spot" because of the charred earth found there. Found here were six screws, one spring, one bent metal piece, one broken drill bit and one screw with the head missing. If the search of this location revealed anything, it was that Art Seale wasn't careful covering his tracks. It was symptomatic of the man himself. "He could do the master plan and each phase of the planning, but when it came to tying the bow on the package, he couldn't do it," said Ed Petersen.

Once this area was photographed and the evidence logged and bagged, the scuba divers began searching the river. Prior to beginning the search, they divided the river into twelve sections. This was to keep uniformity to documentation of any evidence recovered and its exact location for when the case went to trial. The search took hours, but the river was a treasure trove of evidence—pieces of metal in varying shapes, shoe heels, a lighter, a latex glove, garbage bags, pieces of leather from a shoe, plywood, a button, a belt buckle, eyelets from a shoe, a lock hasp, a bolt with a nut, nails, screws, pieces of duct tape, a shoe insert and charred wood were found.

Hours later at the Reso home, Tom Cottone and John Walker were the ones who presented Sidney's ring to Patricia Reso. The drive down her long driveway seemed surreal. The case was long, the emotions deep, and now the ordeal had come to an end. The emotions and exhaustion felt by the two agents paled in comparison to Patricia and her children.

When the agents rang the doorbell, Patricia Reso answered with a grim look on her face. She had been told Jackie said her husband had died, but

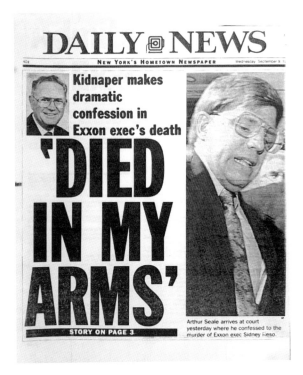

New York Daily News headline. *From the* New York Daily News.

the return of her husband's wedding ring seemed to bring about the finality more than the spoken word. Sid was dead!

The agents told Patricia what they learned from speaking with Jackie Seale. Sid had passed away on Sunday, May 3. The recordings she had heard were Sid, though she had thought it wasn't the voice of her husband. She asked to hear the recordings again. "This time, her and her children could hear it," recalled Cottone. It was Sid's voice. It was an experience the two lawmen would never forget. The heartache in Patricia and her children's expressions was unbearable.

BETRAYAL AND GREED

TUESDAY, JUNE 30, 9:30 A.M.

In a hushed, packed courtroom, Jackie Seale appeared before U.S. district court judge Garrett E. Brown dressed not in prison garb but a navy-blue blazer and a white polo shirt. She had accepted a plea deal that could leave her with a forty-year prison sentence. Jackie knew she was in a world of trouble, and state charges would soon be coming. Her hope was that if she cooperated and testified against her husband, this would be taken into consideration.

U.S. district attorney Michael Chertoff asked Jackie a series of questions in front of Judge Brown. With each question, she answered in the affirmative, indicating her involvement in the kidnapping and imprisonment of Sidney Reso. After Chertoff went over each detail, from the abduction to placing him in a box to burying their victim in a shallow grave in the Pine Barrens, Judge Brown asked, "You understand that you will be a convicted felon by virtue of your own statements?" She answered yes. "You knew what you were doing was wrong?" Brown asked. "Yes," she said.

Speaking on Jackie's behalf was defense attorney Sally Ann Floria:

> She was abused and manipulated by her husband. When this is over, people will have seen that Jackie Seale is basically a very nice person. Without her cooperation, this case would not have been solved, the body

of Mr. Reso would not have been found. Her desire for a decent burial for
Mr. Reso overshadowed concerns for her own well-being.

The first part of Floria's statement seems disingenuous. However, Floria was correct that, without Jackie's cooperation, the case might not have been completely solved. Despite having a specimen of her bleached blond hair, at the time DNA testing and analysis was less than six years old and had yet to go through the legal challenges on admissibility as evidence. The likelihood of authorities identifying that piece of evidence as Jackie Seale's hair was doubtful. Brian Doig's instincts to not allow Jackie to speak with Art "turned out to be a good move," said Petersen. "I think he would have told her to not say anything. That we don't have any physical evidence and let it rest." The Seales could have simply told authorities they did not kidnap Reso but were copycats looking to get rich off the horrible situation. If they had taken this route, authorities might have never found the evidence in the Musconetcong River. Even with their findings in the river, authorities would have no idea what the debris meant. They did not

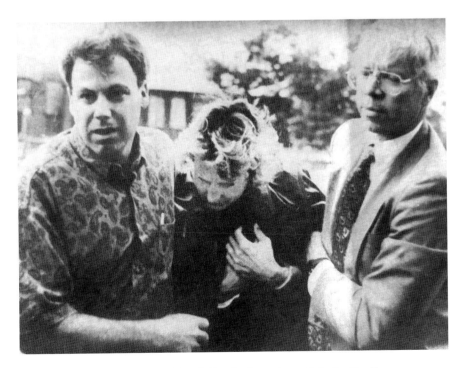

Jackie being escorted into court. *From the* Star-Ledger, *photograph by Pim Van Hemmen.*

know anything about the wooden box until Jackie told them about it. And although the Seales would still have been looking at prison time, it would have been less than what they were now facing.

The proverbial carrot on the stick for Jackie was a reduced sentence of twenty years instead of the forty she was looking at. Part of the arraignment was to place Jackie at a federal penitentiary close to her children. Later, when criticized about the compassionate sentence Jackie was given, Chertoff said, "What she is facing now is pretty much what she would have faced had there been no plea agreement. Her hopes for getting out of prison relied heavily upon the judge." Judge Brown agreed. "Any such promise," he declared, "would be worthless. Nobody knows what sentence I will impose. I don't even know what sentence I will impose until I review the presentence report."

State charges were still lingering over Jackie. "They were reckless, they were desperate, and they were mean spirited. That's a toxic combination for anyone who has a criminal bent," said the Morris County prosecutor, Michael Murphy. Jackie's attorney was doing her best to get a state deal, which would run concurrently with her federal sentence.

12:00 P.M.

Appearing before the same judge, Arthur Seale entered the courtroom in a disheveled dark blue business suit and a white shirt opened at the collar. He said nothing but "Yes sir" and "No sir" to a series of questions. Seale then entered a not guilty plea.

When Seale was walked outside of the federal courthouse, a group of photographers snapped pictures, with one of them capturing Seale with a smile on his face. One of the reporters asked what Art thought about Jackie cooperating and testifying against him. Presumably this was the first he was hearing of it. He simply responded by saying, "Tell her I love her."

When the metal door latched shut and Art Seale sat alone in his jail cell, his world as he knew it was gone. Jackie betrayed him. He had betrayed his children and his father's trust. The reality of the situation he now faced was evident. If only his wife had remained silent, as he certainly would have told her to, the outcome would be much better for him. However, with Jackie testifying, he was sure to spend the rest of his life behind bars. The only hope he had was to beg for mercy. Maybe—just maybe—he would eventually see the light of day again.

Newspaper sketch of Art Seale in court. *Associated Press sketch.*

Months passed before Seale would have the opportunity to offer his plea. While he sat waiting for his court appearance, investigators were building their case. Federal and state prosecutors worked together to bring legal charges against him. Jackie told the court she was manipulated by her husband and fell victim to his scheme to kidnap Sidney Reso. Art Seale's attorney, Chester Kelly's only option was to get his client to admit to his wrongdoing and ask for leniency.

MONDAY, NOVEMBER 30

It was a bright and crisp day when Patricia Reso and her children arrived at the district court in Newark for the federal sentencing of Arthur Seale. The court was packed as anticipated. The family entered the courtroom, and silence filled the air. They sat in the first two rows behind the prosecutor and defense attorney's desks. Directly in front of them, high above these two desks, sat Judge Garrett E. Brown.

Part of the sentencing process allows for family members to speak before the judge, with the accused being required to listen. This allows the judge to hear the impact the crime has had on the victim's family. Sidney Reso was not

the only victim of Art and Jackie Seale. If the judge had read the report—which he certainly did—he knew that Sidney Reso was an honorable man; a man of tremendous success; a man who was respected and admired; and a man, who despite his high-powered position, was an ordinary person who cared about others. Sitting back in his leather chair, the judge listened to Reso's family. In a heartfelt statement, Christopher Reso spoke:

> *My father had a deep influence on myself and my siblings, as all good fathers do. He taught us how to live with high standards for ourselves and those around us. He taught us about responsibility, caring, compassion and love. His loss is devastating.*
>
> *No words can describe the anguish that my family and I experienced the first days and weeks of this ordeal.*
>
> *We loved Dad and only wished for his safe return. But as time passed, it became evident to me that something had gone terribly wrong.*

Not far from where Christopher was speaking, Arthur Seale sat expressionless. There didn't appear to be any remorse in the man's soul. The actions he took against Sidney Reso indicated Seale to be a troubled man whose greed and selfishness were the only guidelines in his life. Christopher continued:

> *We had to listen to the tapes of my father, obviously frightened and in terrible pain, giving directions to a drop that was to take place after he was already dead.*
>
> *The nightmare of what has happened stays with me and is played out every night in my mind as I try to sleep. It is a nightmare that I will have to endure for the rest of my life.*

Those glancing over at Patricia Reso as her son spoke could see a strong woman; someone who endured nearly two months of anguish and the death of her husband, as she had, was surely strong.

Afterwards, it became time for Judge Brown to administer his sentence. Seale was made to stand. Brown seemed to ignore him while he looked at paperwork on his desk. When he was done, he slowly looked up and took off his glasses. "You," Brown said to Seale, "will receive the same mercy you showed your victim." The judge then sentenced the forty-five-year-old Seale to ninety-five years in federal prison. To Judge Brown, the sentence was not enough; "Although the law will not stoop to your callous level, you will die

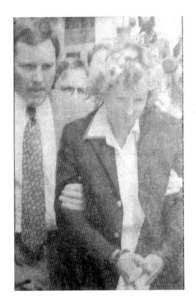

A life gone wrong. *From the Star-Ledger.*

in captivity like your victim." Brown was alluding to the restrictions he had due to federal sentencing laws.

Hours later, in the state courthouse in Morristown, Renee Reso stood before Judge Reginald Stanton and spoke of her father before the state rendered its sentence: "Never could we have imagined the true horror of his circumstances. That my father was placed in a box. That he was unable to eat. That he was unable to see. That he was unable to go to the bathroom. That he was unable to breath well due to the poor ventilation and heat in that storage room."

As Renee spoke, you could hear a pin drop in the courtroom. Her mother, brother and two sisters sat in the first row, while other family members were in the second row. Referring to Seale, not ten feet away, Renee told the judge, "He tormented family members for more than a month, telling them in communications that he was alive while threatening to kill him if the ransom was not paid." This took place while her father was buried in a shallow grave. Seale "thought he deserved instantaneously that which my father worked for his whole life." Sorrow resounded in her voice. "Because of Mr. Seale's lust for money, because of his evil, he took from me the person that I admired most in the world, the person that I respected. He took my father, who I turned to for advice and encouragement."

After Renee concluded her statements, Robyn and Cyd Reso stood and spoke of their hurt, their father's love and the "unbelievable coldness, callousness and calculated evil" used against their father. After they finished, Judge Reginald Stanton requested Arthur Seale to stand as he spoke:

> *The safety of the community requires you to be imprisoned for the remainder of your life so you will never again pose a danger to the human community.*
>
> *I'm aware you may die in federal prison before starting the sentences I am imposing today, but parole rules may someday change. If so, it is imperative that you never again be at liberty.*

Stanton sentenced Arthur Seale to a life term without the possibility of parole until forty-five years had passed. Then, Stanton added another thirty-year prison term for the kidnapping charge. As the sentence was brought down, the Reso family "embraced one another and sobbed." Later, speaking of the hearings, Patricia indicated it was like a horror movie. "When they talk in the courtroom about the murder of Sidney J. Reso, it's just words…but it's not Sid.…It's a really strange thing to try to explain." To those listening, it was not. She and her children were going through the unimaginable.

EPILOGUE

A month after burying her husband, Patricia Reso sat for an interview wearing her husband's gold ring around her neck. "I'm stronger," she said. "I'm sadder. I'm certainly different." Fortunately, several years later, love would find her again, and she remarried. Tragedy would strike Patricia and her family twice more in the years that followed; her son Christopher and her son-in-law Peter would both pass away. The anguish Patricia Reso experienced in her lifetime was more than anyone should have had to endure. On August 19, 2011, at the age of seventy-seven, Patricia passed away. She is buried alongside Sid Reso.

Irene "Jackie" Seale served almost eighteen years in a federal prison in Connecticut before her release in January 2010 at the age of sixty-three. She spent five years on probation living in Illinois. Today, Jackie Seale is a free woman.

Courtney and Justin Seale were put in the custody of Arthur Seale Sr. and his wife, Daphne. Courtney and Justin were also victims of Art and Jackie Seale. As a result, they have had difficulties throughout their young lives. They are now in their forties.

At this writing, Arthur D. Seale Jr. is at the Federal Medical Center in Fort Devens, Massachusetts. Through the years in his confinement, Seale earned an undergraduate degree and a graduate degree before obtaining a doctoral

degree in psychological counseling through correspondence study. It is said he has spent hours "typing out letters to newspaper editors and suggesting that perhaps someone—anyone—might want to come listen to his story and write a different ending." There can only be one ending to this horrible tale. The one solace for the Reso family that can come from this horrific story is that Arthur Seale will die in captivity and will never enjoy the comforts of life he desperately coveted and craved. Rather, he sits in a concrete cell with cold metal bars as his decor.

SOURCE INFORMATION

Most of the material contained in this narrative was taken from interviews with law enforcement personnel involved in the Sidney Reso investigation and those people who knew Arthur D. Seale. Newspapers and their journalists did an excellent job detailing the investigation as it unfolded over a fifty-eight-day period, and I'm grateful for that resource. The following newspapers, with their detailed accounts of the Sidney Reso investigation, played a key role in developing this narrative:

Courier Post (South Jersey)
Daily Record (Morris County, NJ)
Detroit News & Free Press
Express Times (Warren County, NJ)
Hunterdon Review (Hunterdon County, NJ)
Jersey Journal (Hudson County, NJ)
Morning Call (Allentown, PA)
Newsweek
New York Daily News
New York Post
New York Times
North Jersey Herald & News
People
Philadelphia Daily News
Philadelphia Inquirer

Record (Bergen County, NJ)
Star-Ledger (New Jersey)
Sunday Record (Bergen County, NJ)
Times of New Jersey
Trentonian (Newark, NJ)
U.S.A. Today
Wall Street Journal
Washington Post

ABOUT THE AUTHOR

John E. O'Rourke was born in Pequannock, New Jersey, and raised in the Passaic County town of Wanaque. He is a retired New Jersey state trooper with twenty-six years of experience with the elite organization. During his distinguished career, he conducted hundreds of criminal investigations ranging from criminal trespass to murder. In addition to his writing, Mr. O'Rourke is a security consultant. He has authored the books *Jersey Troopers: Sacrifice at the Altar of Public Service, New Jersey State Troopers: 1961–2011: Remembering the Fallen* and *The Jersey Shore Thrill Killer: Richard Biegenwald.*

Visit us at
www.historypress.com